WILLEM
DE KOONING

WILLEM
DE KOONING

SALLY YARD

EDICIONES POLÍGRAFA, S.A.

For Alex

I am grateful to a number of friends and colleagues who have played a role in this project. Sam Hunter has been unwavering in his support and incisive in his observations. Robert Rosenblum, Richard Martin, Allen Rosenbaum, Jill Guthrie, Hugh Davies, Marla Prather and Julie Dunn have sharpened my thinking about de Kooning's work. With generous spirit and candor, Annalee Newman, Rudy Burckhardt, Max Margulis and Thomas Hess shared their recollections. Elaine de Kooning and Joan Wolff were invariably energetic cohorts in pursuit of the facts and phantoms of the past. Allan Stone, Claudia Stone, Edvard Lieber and Greg Sholette have all helped to ferret out important material. The verve and indefatigable resourcefulness of Roger Anthony, Jennifer Johnson and Amy Schichtel, of the Willem de Kooning office in New York, have been crucial. Juan de Muga, Solveig Williams, and Anna Angrill have been patient and astute throughout.

CONTENTS

Willem de Kooning, c. 1950. Photograph by Rudolph Burckhardt.

WILLEM
DE KOONING

BY SALLY YARD

Docking at Newport News, Virginia, in August 1926, Willem de Kooning was inclined to stay aboard the SS *Shelley* as it headed south for Argentina. But Leo Cohan, the friend who had arranged de Kooning's unofficial arrival in the United States, swiftly guided the wayward emigré from Holland ashore. Another boat trip and some days later, the twenty-two-year-old de Kooning was in Hoboken, where he would make a living as a house painter, his first American address a Dutch Seaman's Home. Within the year he had moved to Manhattan, working as a sign painter and department-store display designer, taking on carpentry jobs, and occasionally painting murals for speakeasies.[1] De Kooning's plan in leaving Rotterdam had hardly been for a career as a fine artist. That, he has reflected, would have been an ambition better pursued in Europe, where the latest tendencies might be followed first-hand and Paris was just a train ride away. Rather, his was a dream of prosperity: to become a commercial artist, make money, play tennis, and find "those long-legged American girls."[2]

Yet by 1950 de Kooning was one of the leading figures of the inter-national avant-garde. If the ardent abstractions that comprised his first one-person exhibition in 1948 established the forty-four-year-old artist's reputation, in 1953 he stunned the public with *Paintings on the Theme of the Woman*. From the start in New York, de Kooning was committed to the dual agendas of figuration and abstraction. As he struggled to paint like both Ingres and Soutine,[3] he built his strategies on seemingly irreconcilable bases. Although de Kooning was notorious among friends for his relentless reworking of paintings, he became famous with a wider audience for the presumed recklessness of his methods. Scrutinizing the art of Picasso and Giacometti, the objects of the ancient Near East and Greece, the saints of Byzantium, de Kooning gradually arrived at a voice that was distinctly postwar and resolutely his own.

De Kooning's paintings are rooted in his particular experience, even as they track the shifting tenor of New York. The tentative and sombre men painted in the thirties invoke the bleak prospects of the Depression years. Fraught with tension, the black-and-white abstrac-tions of 1946–49 probe the meaning of action in a world shadowed by the Second World War. As the fifties open, triumphant women glare like pinups turned guerrilla girls. Four years into that decade of affluence and McCarthyism, the devouring seductresses retreat to make way for madcap beach-goers. The raucous girls-next-door are soon absorbed into robustly brushed abstractions redolent of the city and of the slow curves and long vectors of the highways.

While the cigarette-ad smile of de Kooning's *Woman* (1950) was the indubitable presence behind such pop icons as James Rosenquist's billboard-sized *Candidate* (1963) and Andy Warhol's *Marilyn Monroe's Lips* (1962), the heyday of abstract expressionism was over by 1960. Hounded by admirers, by all accounts a star, de Kooning left Manhattan in 1963 for a studio at the far end of Long Island. The coloristic heat of *Pastorale* (1963) and voluptuous surfaces of *Woman, Sag Harbor* (1964) and *Woman Accabonac* (1966) screen the tortuous core of conflict that endures even into this reputedly Rubensian moment, as if the dream of Eros veils a dread of Thanatos.

From images of men that metamorphose into women in the thirties and forties to women whose embrace unfurls into a cross in the sixties, de Kooning probed a psychological continuum that reaches from masculine reticence to feminine ferocity. "You can't always tell a man from a woman in my painting. Those women are perhaps the feminine side of me—but with big shoulders."[4] In de Kooning's work, the expression of demonstrative emotion is tied to the female form, as impassive men blanch beside their buxom contemporaries. Each phalanx of Circean femmes fatales in paint is paralleled, from 1950 onward, by drawings of bewildered, crucified men.

Abstraction overtakes the figure in the seventies—as in the fifties—the palette lush now with the hues of underbrush and a luminosity that is oceanic. Brushed strokes and palette-knifed sweeps of pigment float or submerge across the nearly square canvases that de Kooning preferred at this time. In defiance of receding memory, the paintings in the eighties resonate with de Kooning's past. Taking its cue from a seated figure in *Untitled (Seated Woman on the Beach)* (1966–67),[5] an untitled work of 1986 looks to be the summation of a painter who fifty years earlier had gingerly composed in the primary colors of his compatriot Mondrian an image entitled *Father, Mother, Sister, and Brother* (c. 1937).

For all their differences, the artists who came to be called abstract expressionists—Mark Rothko, Barnett Newman, Jackson Pollock, Clyfford Still, Adolph Gottlieb, Robert Motherwell, Franz Kline, and de Kooning among them—were by the close of the forties united in their avoidance of narrative subject matter. The New York art world during the thirties had been dominated by the eminently recognizable imagery and sober-minded scenarios of social realism and American scene painting. But the American Abstract Artists (AAA) group, formed in 1937, had countered those homespun tendencies in work that was patently indebted to Dutch De Stijl. Although de Kooning would later reflect "I was with them," the anatomical evocation of his own abstract paintings diverged from the nonobjective style generally espoused by AAA members. De Kooning never joined: "I disagreed with their narrowness, their telling me *not* to do something." A decade later, discussions at the Club, set up in 1949, affirmed the enduring and shared belief that art—whether geometric or organic in allusion—must spurn depiction in order to achieve expression. "With us the disguise must be complete,"

Rothko wrote. "The familiar identity of things has to be pulverized in order to destroy the finite associations with which our society increasingly enshrouds every aspect of our environment."[6]

De Kooning was alone among the American abstract expressionists in his persistent confrontation with the human figure. "If you pick up some paint with your brush and make somebody's nose with it," he mused in 1960, "this is rather ridiculous when you think of it, theoretically or philosophically. It's really absurd to make an image, like a human image, with paint, today. . .since we have this problem of doing or not doing it. But then all of a sudden it was even more absurd not to do it."[7] Yet by 1946 the terrain occupied by de Kooning's figures was unstable and aggressive, registering its rifts across a Richter scale of flesh. With the unsettled line and shifting contours of the thirties and forties and in the viscous paint and impassioned brushstrokes of the fifties, sixties, and seventies, de Kooning forced to the fore the processes by which the paintings were made. Posing as the outbursts of an unruly psyche, the works were constructed according to a "physics of perceptual structure"[8] that proved to be inimitable.

Impulse is answered inevitably by deliberation in de Kooning's paintings, as if to embody the countervailing pressures that are as ancient as the myth of Theseus and the minotaur, as timeless as the story of the Crucifixion, as modern as the schema of the ego and the id. If the English painter Francis Bacon could assert with cool, post-Nietzschean nihilism that "we are born and we die, but in between we give this purposeless existence a meaning by our drives,"[9] then de Kooning would search the forces that frame human experience in terms that overlaid Kierkegaard and Aeschylus. For all his careful reading of the Danish philosopher, de Kooning was unwavering in his conviction that there is no possibility of choosing either/or. Neither the "aesthetic" sensualism figured by Kierkegaard in *Either/Or*'s (1843) fictive author A, nor the "ethical pathos" with "its infinite passion of resolve" of B can, for de Kooning, stand alone.[10] It is, instead, in the entanglements of body and mind, desire and will, drive and judgment that our lives take shape.

• • •

By 1927 de Kooning was a consistent viewer of Manhattan's exhibitions. In January he was awestruck by Henri Matisse's work at the Valentine Dudensing Galleries, rushing home "to keep that feeling." He immediately began to paint "his Matisse," *Still Life* (1927), dominated by that "cobalt violet—I had to have that."[11] De Kooning in time recomposed the still-life elements into an abstraction, *Untitled* (c. 1931), the window and table made into orange parallelograms that read alternately as flat shapes on a flat surface and as geometries that project three-dimensional space. The nearby Dudensing Galleries, run by the same family, afforded the occasion for another pivotal encounter in

1

spring 1929. Observing the disarming antics of a man giving "some women a hard time" at an opening party, de Kooning was startled to discover that the elegant culprit was not the dealer but the artist. Yet de Kooning had intuited the double roles of the flamboyant Russian-born painter John Graham. If Graham's work had by now been exhibited in America and in Paris, then he too was a connoisseur of note, traveling abroad to assemble objects for the Crowninshield collection of African art,[12] returning to New York with enraptured reports of the latest developments in Europe.

Within a year or so, de Kooning and Arshile Gorky were introduced at Mischa Resnikoff's studio: "I met a lot of artists—but then I met Gorky. I had some training in Holland, quite a training, the Academy. Gorky didn't have that at all. He came from no place; he came here when he was sixteen, from Tiflis in Georgia, with an Armenian upbringing. And for some mysterious reason, he knew lots more about painting and art—he just knew it by nature—things I was supposed to know and feel and understand—he really did it better. He

2

had an extraordinary gift for hitting the nail on the head; very remarkable. So I immediately attached myself to him and we became very good friends."[13] While de Kooning's social life in the thirties was set in the late-night cafeterias of lower Manhattan, his investigations of art drew him, often in the company of Gorky, to the Metropolitan Museum, the Frick Collection, the Museum of Modern Art, and the commercial galleries.[14] Gorky's certainty that an artist must be steadfast in studying work past and present was made cuttingly clear during his first visit to de Kooning's studio. "Aha, so you have ideas of your own," Gorky had observed, leaving de Kooning with little doubt that "somehow that didn't seem so good."[15]

It was probably in a restaurant called Romany Marie's that de Kooning first spoke with Stuart Davis.[16] Energized by the 1913 Armory Show, the Philadelphia-born Davis had with shrewd originality probed cubism: clearly it was possible for a painter working in New York to absorb the lessons of European abstraction and to elude the provincialism of a city that remained an artistic outpost. Although the opening of

2.
Untitled, c. 1931.
Oil on canvas,
23 7/8 × 33 in.
(60.6 × 83.8 cm).

New York's Museum of Modern Art in November 1929 attested to a mounting interest in recent developments, the crash of the stock market two weeks before had projected a decade of financial devastation for artists and patrons alike. At the first American Artists' Congress in February 1936, painter Max Weber spoke to the group assembled to confront the dire situation in the United States and to work against fascism abroad: "In the beginning of his or her career, the artist is advised to make connections. We keep on connecting all our lives, and in the end most of us find ourselves connected with the poor house."[17]

If Davis, Gorky, and Graham were viewed as the three "magus figures"[18] of the downtown New York art scene in the thirties, then for de Kooning it was Gorky and Graham—immigrants like himself—who were "the ones."[19] "It was nice to be foreigners meeting in some new place. Of course, New York is really like a Byzantine city—it is very natural too."[20] But the exhilaration and sense of possibility were subdued by the pervasiveness of poverty. In 1935 the Works Progress Administration's Art Project was launched to mitigate the desolation. Photographer and filmmaker Rudy Burckhardt recalled that "for a year or more Bill was on the WPA Artists' Project, the so-called $23.50 Club; that's what you got paid a week (not bad at all) for doing your own work and delivering a small painting once a month. But as the war came nearer and Republicans objected to abstract paintings being made at the government's expense, proof of citizenship became required and Bill, who had come over as a stowaway from Holland and had no papers at all, had to get off."[21] Burckhardt and Edwin Denby (by the forties known as a poet and dance critic) were de Kooning's next-door neighbors on West 21st Street in 1935 and became the first staunch collectors of his work. The stint with the WPA produced several studies for a mural at the Williamsburg housing project in Brooklyn, one of these included in the Museum of Modern Art's 1936 *New Horizons in American Art*. De Kooning also worked briefly with Fernand Léger and a team of other artists on plans for a mural for the French Line pier. Neither project was realized, but de Kooning's self-image was transformed: "Even after the year I was on, I changed my attitude to art. Instead of doing odd jobs and painting on the side, I painted and did odd jobs on the side. The situation was the same but I had a different attitude."[22]

De Kooning's ventures into abstraction were impelled onward by *Cubism and Abstract Art* and *Fantastic Art, Dada, and Surrealism*, presented in quick succession in spring and winter 1936 at the Museum of Modern Art. The pair of exhibitions laid out a framework of the abstract rigor of form and subconscious prompting of content within which abstract expressionism would take shape in the forties. That these dual currents were crucial was reiterated in Graham's book *System and Dialectics of Art*, published in 1937. Proposing Picasso as the summit of art's development since prehistory, Graham effused that "in all human history, perhaps he more than any other man has pried open the secrets of nature and genesis." Pronouncing that art must delve into

3

4

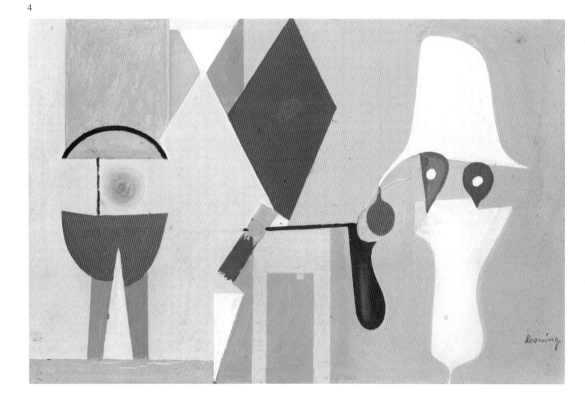

3.
*Father, Mother, Sister,
and Brother*, c. 1937.
Oil on board,
12 × 22 ½ in.
(30.5 × 57.1 cm).

4.
Untitled, 1939–40.
Oil on mat board,
8 ½ × 12 ¾ in.
(21.5 × 32.4 cm).

5

the unconscious, Graham advocated the enlistment of automatism and "intuitive revery."[23]

De Kooning's first efforts to come to terms with Picasso revolved around his response to *The Studio* (1928), given to the Museum of Modern Art in 1935. A pair of *Untitled* paintings of 1937 and 1939–40 rethink in small scale Picasso's schematic 7¹/₂-foot-wide image of the artist painting a still life inhabited by a sculptural bust. In 1937 de Kooning was commissioned to design a ninety-foot mural—one of three—for the Hall of Pharmacy of the 1939 World's Fair, based in Flushing. Studies reveal the abstract, Picassoid beginnings of the *Medicine* image, which in the end assumed a more legibly figurative form. The full-scale version was realized by professional sign painters. "You could watch it roll by," Burckhardt remembered, "driving on the Long Island Expressway."[24] If *Medicine* celebrated the advances of science in the most public work de Kooning would ever make, in smaller paintings like *Father, Mother, Sister, and Brother,* de Kooning probed a

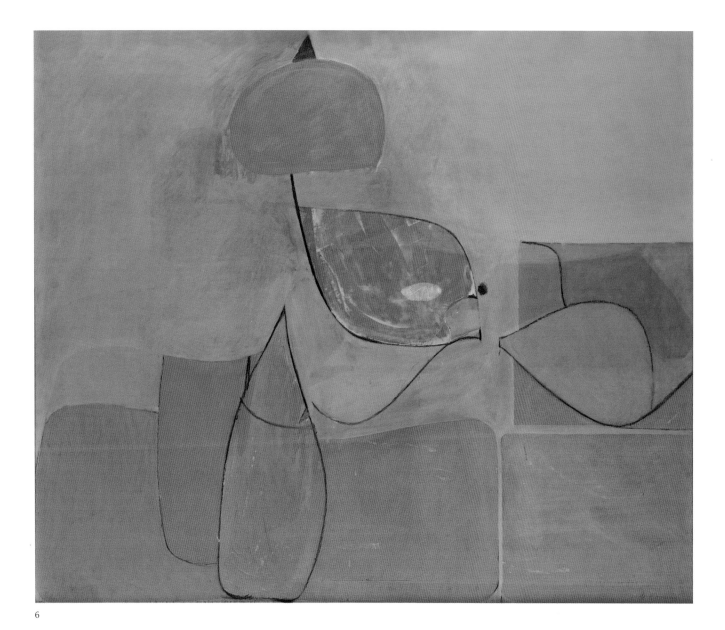

6

more private imagery. The abstractions of the thirties culminated in such lyrical images as *Elegy* (c. 1939), a composition of pink podlike shapes across an aqueous aquamarine field.

While the titling of *Father, Mother, Sister, and Brother* probably followed the completion of the painting, which was devoid of recognizable imagery, de Kooning might have wished to rethink, to regroup the family. The second child of the fractious marriage of Leendert de Kooning, a wine, beer, and soft-drink distributor in Rotterdam, and Cornelia Nobel de Kooning, who ran a cafe frequented most steadily by sailors, his early years had been tumultuous. The custody arrangements that accompanied the de Koonings' 1907 divorce placed three-year-old Willem, born in April 1904, with his father, to whom he was notably close. His eight-year-old sister was to live with their mother. But Cornelia—irate and fearsome by some accounts—swiftly retrieved her son and ultimately succeeded in reversing the court's decision.[25] De Kooning gave up grammar school at age twelve for an apprenticeship

6.
Elegy, c. 1939.
Oil and charcoal on composition board,
40 1/4 x 47 7/8 in.
(102.2 x 121.5 cm).

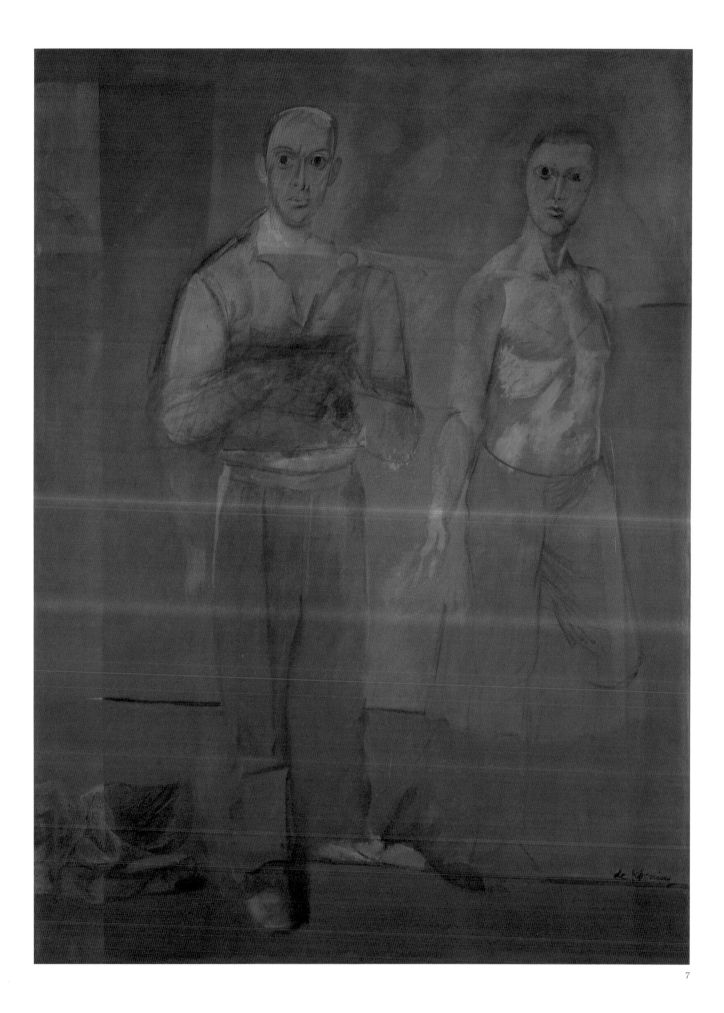

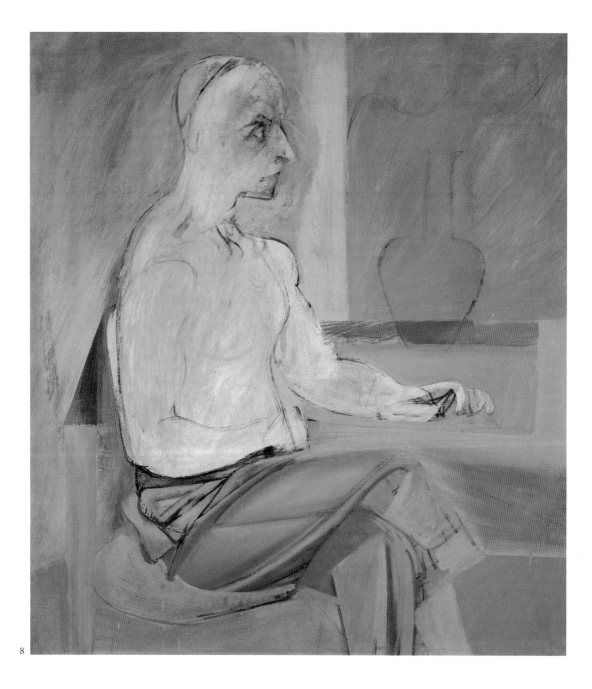

8

with the commercial art firm of Jan and Jaap Gidding, studying in the evenings until 1921 at the Rotterdam Academy of Fine Arts and Techniques. At sixteen he left home to share a studio with friends, and during the next five years worked as a commercial artist in Rotterdam and, briefly, in Belgium, as he would in New York.

As the thirties drew to a close, de Kooning focused primarily on images of men. From *Two Men Standing* (1938) and *Seated Man* (c. 1939) to *The Glazier* (c. 1940), the solemn figures are set in a shallow, rose-tinged space. Poses and anatomies were worked out in dozens of drawings, as de Kooning most often studied his own image in the mirror and, occasionally, in photographs. A manikin constructed by the artist may account in part for the inordinate stiffness of the folds of pant legs in the paintings of men. "I took my trousers, my work clothes. I made a mixture out of glue and water, dipped the pants in and dried

7.
Two Men Standing,
1938.
Oil and charcoal
on canvas,
61 x 45 in.
(155 x 114.3 cm).

8.
Seated Man, c. 1939.
Oil on canvas,
38 ¼ x 34 ¼ in.
(97 x 87 cm).

in front of the heater, and then of course I had to get out of them. I took them off—the pants looked so pathetic. I was so moved, I saw myself standing there. I felt so sorry for myself. Then I found a pair of shoes—from an excavation—they were covered with concrete, and put them under it. It looked so tragic that I was overcome with self-pity. Then I put on a jacket, and gloves. I made a little plaster head. I made drawings from it, and had it for years in my studio. I finally threw it away. There's a point when you say enough is enough."[26] Friends, too—Burckhardt, Denby, musician and music critic Max Margulis—were enlisted as models. During sessions in the studio, Denby sometimes read—Gertrude Stein,[27] perhaps James Joyce—to de Kooning.

Line is restless, figuring alternatives for the hands of the man at left in *Two Men Standing*. Exacerbating the impression of indecision, a pose with right arm lowered seems to have been left over from some earlier version. The knickers of the man at right accommodate a riveting innuendo, as the bare-chested man appears also to be a woman, with a chalk-white-bodiced ballet costume and a faintly drawn coiffure. At far left, a charade of chiaroscuro is played out, as de Kooning juxtaposes flatly painted rectangles—one light, one dark—above, with opulently described, unabashedly stylized folds of cloth below. It is a tour de force of three-dimensional rendering subverted by the rectilinear swath of light that cuts through geometry and drapery alike.

De Kooning's laments during the thirties and forties about the difficulties of rendering hands and shoulders, the dread demands of hair, the appalling impossibility of foreshortened thighs were notorious among his friends: "You could lose your mind."[28] Drumming his fingers on a beryl green table, *Seated Man*, like *The Glazier*, seems devised at once to confront and evade the troublesome passages. The artist's resistance to finishing paintings was well known; his complaints that "I'm beating my brains out" occasionally elicited an ill-received endorsement of psychoanalysis. "Sure, the analyst needs me for his material the way I need my pictures for mine."[29] Given the tenuousness of de Kooning's finances, the reusing of canvases, front and back, was an act of economy as well as of anxiety. "Often Bill couldn't sleep and late at night would walk all the way to the Battery and back again. When offered a drink to relax with he'd refuse, saying, Oh no, a drink wouldn't do anything for him, and take another long walk instead. Much later it was success that started him drinking."[30] When de Kooning didn't head for the piers where Melville's Ishmael had gone for solace, he sometimes walked in Washington Square Park. On one late-night excursion he for the first time met Rothko, sitting on a bench.[31]

The extensive black-and-white illustrations in the copies of the periodical *Cahiers d'Art* brought back from Paris by Graham kept de Kooning and Gorky apprised of Picasso's progress. Yet nothing could have prepared them for the exhibition *Picasso: Forty Years of His Art*, which opened in November 1939 at the Museum of Modern Art and which proved "staggering."[32] From *Les Demoiselles d'Avignon* (1907) to

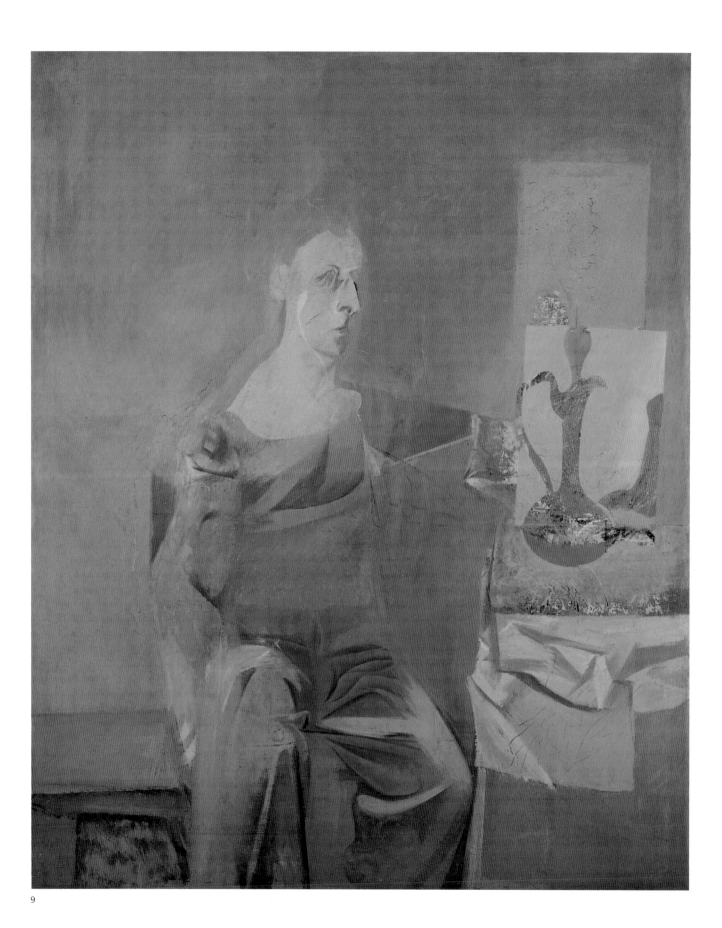

9

9.
The Glazier, c. 1940.
Oil on canvas,
54 × 44 in.
(137 × 111.7 cm).

19

10

Guernica (1937), Picasso's melding of figurative subject matter, abstract form, and vehement content was "prodigiously important."[33] It was not, however, the emotional pitch of these extremes of Picasso's expressive range that initially surfaced as de Kooning absorbed the exhibition's impact.

De Kooning's immediate response was to transmute the brutal aggression of *Guernica* into the frozen immobility of the pencil *Two Standing Men* (c. 1939). The figures were, de Kooning observed, prompted by "men standing in the subway like manikins."[34] As friends remembered it, the duo with their oversized clothes were based on the window display of a store for "tall men and big men" on the Lower West Side of Manhattan.[35] Whatever the quotidian sources, the men stare ahead with wide, almond-shaped eyes, full lips, and flared nostrils that are borrowed directly from the bulls and minotaurs that surrounded the making of *Guernica*, Picasso's shrill lamentation over the slaughter of Spanish civilians by German bombers deployed by General Franco. Not only did the 1939 Picasso retrospective include the 25½-foot-wide

painting and some sixty studies, but the Museum of Modern Art exhibition had been preceded in May by an installation of *Guernica* and related images at the Valentine Gallery.[36] Held at bay in the men, the ferocity that de Kooning had found in Picasso would break loose in the women, who followed shortly.

• • •

In 1937 de Kooning met Elaine Fried, then a nineteen-year-old art student. "I think it was love at first sight," Burckhardt recalled. "Soon they lived together, painted together, kept the landlord from the door, got married, and were as close as two people can be to each other."[37] Elaine and her sister Marjorie sometimes posed for drawings and paintings as de Kooning turned his attention toward images of women. The first women of the forties sit decorously, as if for portraits by the nineteenth-century French painter Ingres. But the figures grow progressively more agitated, spurred on by Picasso's predatory women of 1929. The avoidance of hands, the trouble with shoulders, the confounding of foreshortening, and the erratic description of hair in the paintings of men escalate in the women. De Kooning worked tenaciously to undo any sense of finality, pressing charcoal line into many of the oil on canvas or board surfaces of the forties. Occupying a field of vibrant, saturated, and unnatural color, *Seated Woman* (c. 1940), *Woman Sitting* (1943–44), *Queen of Hearts* (1943–46), *Pink Lady* (c. 1944) and *Woman* (1944) are engulfed by a pictorial logic that increasingly undoes anatomical cohesion.

Elaine and Willem married in December 1943 and settled on 22nd Street. Their top-floor loft was, Denby remembered, "spacious and high-ceilinged, sunny at the back. When he took it, it had long stood empty. He patched the walls, straightened the pipes, installed kitchen and bath, made painting racks, closets and tables; the floor he covered with heavy linoleum, painting it grey and the walls and ceiling white. In the middle of the place, he built a room, open on top, with walls a bit over six feet high. The bed and bureau fitted into it; a window looked out into the studio. The small bedroom white outside and pink inside seemed to float or be moored in the loft. All of it was Elaine's wedding present. The six months he spent getting it ready were the only time during many years before or later that he put off painting for longer than a couple of days."[38] But soon the artist couple's lateness with the rent and the sale of the building necessitated a move to an apartment on Carmine Street in Greenwich Village and a studio for Willem on Fourth Avenue behind Grace Church.[39]

The incompletion and vacillation suggested by de Kooning's method of working across the paintings with charcoal was intensified by his habit of sanding their surfaces-in-progress. "A new picture of his, a day or two after he had started it," Denby recalled, "had a striking lively beauty. But at that point, Bill would look at his picture sharply,

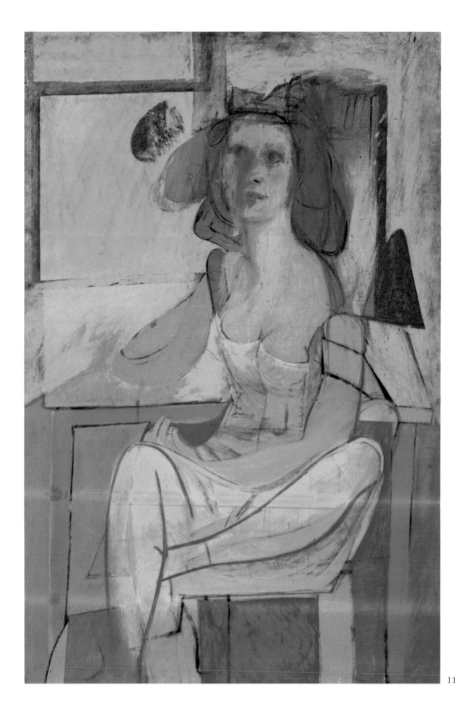

11.
Seated Woman,
c. 1940.
Oil and charcoal
on masonite,
54 x 36 in.
(137 x 91.5 cm).

like a choreographer at a talented dancer, and say bitterly, 'Too easy.' A few days later the picture looked puzzled; where before there had been a quiet place for it to get its balance, now a lot was happening that belonged to some other image than the first. Soon the unfinished second picture began to be pushed into by a third. After a while, a series of rejected pictures lay one over the other. One day, the accumulated paint was sandpapered down, leaving hints of contradictory outlines in a jewel-like haze of iridescence . . . and then, on the sandpapered surface, Bill started to build up the picture over again."[40] De Kooning chose to exaggerate rather than efface the "contradictory outlines." So *Woman Sitting* presides from the second of two pink-and-white chairs formulated by the artist, the veiled, lower, round-backed one visible as if a pentimento. But whereas a genuine pentimento is the unanticipated

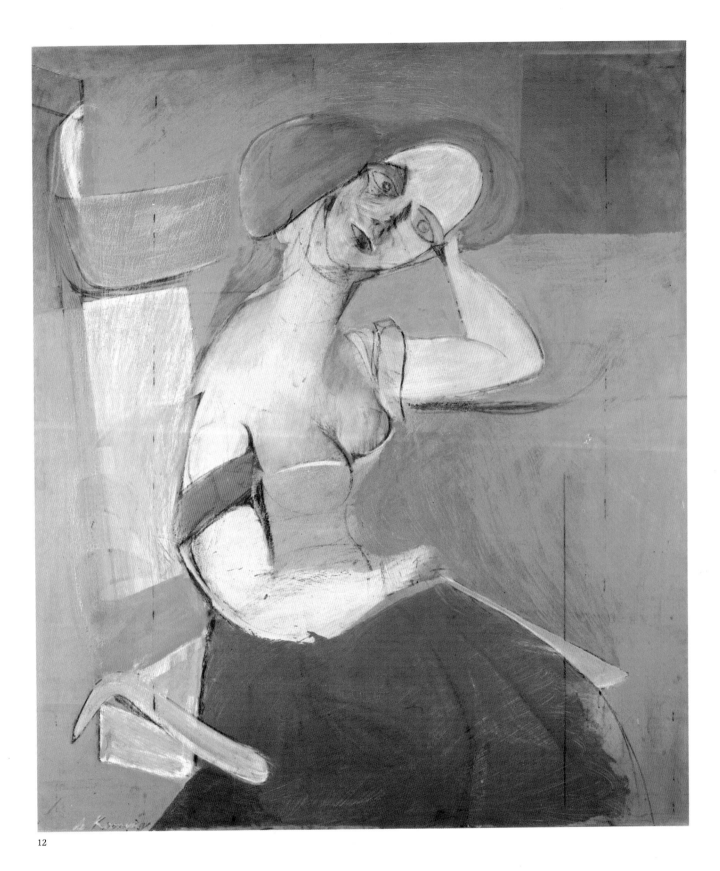

12

12.
Woman Sitting,
1943–44.
Oil and charcoal on
composition board,
48 1/4 × 42 in.
(122.5 × 106.7 cm).

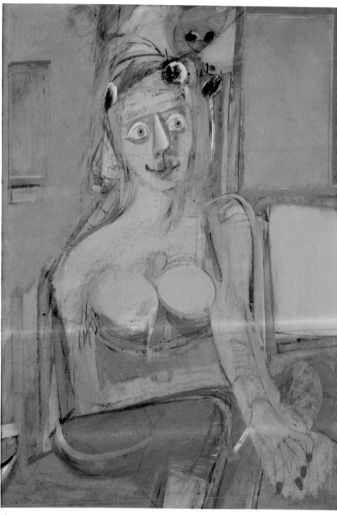

13

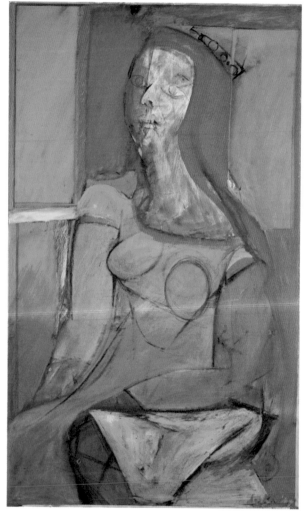

14

13.
Woman, 1944.
Oil and charcoal
on canvas,
46 × 32 in.
(116.8 × 81.2 cm).

14.
Queen of Hearts,
1943–46.
Oil and charcoal
on fiberboard,
46 1/8 × 27 5/8 in.
(117 × 70 cm).

15.
Pink Lady, c. 1944.
Oil and charcoal
on panel,
48 1/4 × 35 1/4 in.
(122.5 × 89.5 cm).

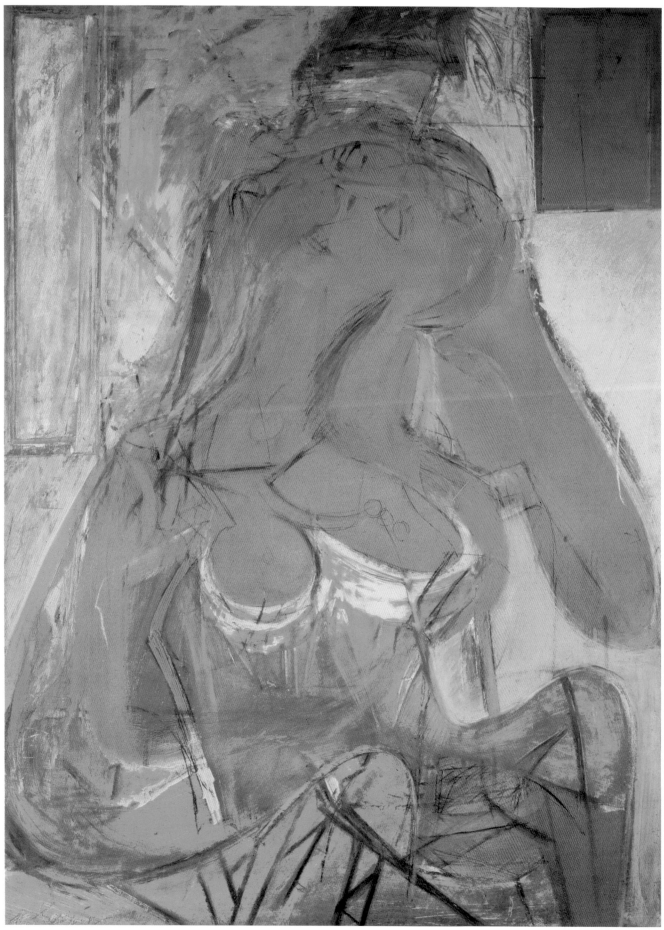

15

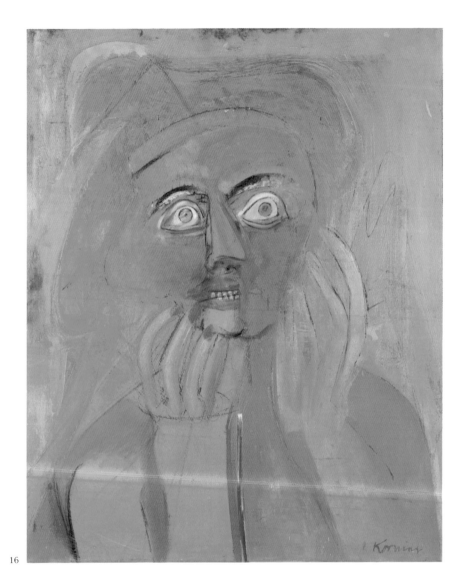

16

reemergence of an idea considered and obscured, exposed over time by unforeseen interactions of materials, in de Kooning's art the effect is deliberate.

If foreshortening is glossed over by the costume of *Woman Sitting,* then in *Woman* (1944) its necessity is circumvented as de Kooning turns knees sideways and folds limbs inward, arm over arm over leg. But the woman's three-dimensionality is affirmed, by the effulgence of the breasts that nearly escape the confines of the bodice and by the fidgeting of the fingers with their red-polished nails. Electric juxtapositions of green and red carve the features of the face as they do the volumes of the body, modeled not by light and shadow but by a push-and-pull of color that is more conventionally played out in the Hans Hofmann-like rectangles that form the shallow space around the figure.

The lurid yellow flesh tones and clownlike fuchsia lips of *Woman* subside into the offbeat pink complexion of *Pink Lady.* But that is all that abates, as the woman digs in against an increasingly contentious surround marked as interior by the rectangles that here, as in Picasso's paintings, stand for windows, pictures, or mirrors on the wall.

17

Brushstrokes and charcoal rove across the surface, at once composing
and dismantling the figure. De Kooning tried out the slapping collision
of frontal and profile visages in a study (c. 1943) on the back of *Black
Friday* (1948) and in *Woman* (1943) as he worked toward the jittery
instability that is exuded by *Pink Lady*. The allusions to Picasso at this
moment are profuse, as *Pink Lady's* pose spins off from images like
Woman with a Book (1932), and as the globular mascara and backward
tilt of the head revisit the *Weeping Women* that were bound up with
the emergence of *Guernica*.[41]

By mid-decade de Kooning had put into action a three-part pro-
gram in the paintings of women. Foreshortening was avoided. The last
traces of perspective were accosted by a push-and-pull of color and a
scattershot of line. And as for chiaroscuro, de Kooning's supposed
indecision served as cover, the troublesome junctures of chin and
neck, the volumes of the body shaded finally by what look like surges
of nervousness and animosity acted out in blurs of line and swipes of
paint. Whatever the emotional pretext or subtext, de Kooning was
strategizing to dispense with all vestiges of illusionistic description.

17.
Unfinished heads,
c. 1943.
Figure studies on the
back of the pressed
wood panel support
of *Black Friday.*
Oil on pressed wood
panel,
39 x 49 ¼ in.
(99 x 125 cm).

In January 1942 Graham arranged an exhibition of *American and French Paintings* for McMillen, Inc., an interior decorating firm. De Kooning, Stuart Davis, Virginia Diaz, Pollock, Lee Krasner, and Graham himself were among the Americans whose works were shown together with those of such revered figures from abroad as Picasso, Braque, Matisse, and de Chirico. New York was by now filled with artists (though not the ones exhibited at McMillen) who had fled the catastrophe underway in Europe. Piet Mondrian, André Breton, Max Ernst, Matta, Yves Tanguy, André Masson, and Marcel Duchamp all arrived in the United States between 1939 and 1942. The friendship and subtle rivalry of de Kooning and Pollock dates from the McMillen exhibition, as does de Kooning's first review, which included a reproduction of a man painted two or three years earlier: "A strange painter is William [sic] Kooning who does anatomical men with one visible eye, but whose work reveals a rather interesting feeling for paint surfaces and color."[42] After this exhibition, de Kooning's work appeared in group shows with some regularity, though he resisted invitations for one-person exhibitions until 1948.

Although Graham had been instrumental in shaping the directions developed by the New York School and was loyal in promoting the work of his artist-friends, he had nonetheless begun to retreat from his earlier modernist commitments. Abandoning psychoanalysis for esoteric, magical systems, and maligning abstraction while hailing the old masters, Graham was by the mid-forties especially disenchanted with Picasso. In a "manifesto" entitled "The case of Mr. Picasso," the former czarist aristocrat's accusations turned reactionary: Picasso's "fame is a great international, money-making intrigue. His art is a hoax."[43] As de Kooning's work grew increasingly charged with Picassoid distortions, Graham would sit with his back to the paintings. He could not, he explained, "stand someone struggling." Nor would he, however, abandon the friend whom he had acclaimed in *System and Dialectics*—five years before any other writer would comment—as one of the "young outstanding American painters." "Bill," he would say, "whatever you're doing is good enough for me."[44]

• • •

The serenity of the abstractions that opened the decade was by 1946 cast aside in favor of the tensions and frenetic rhythms of de Kooning's postwar work. In *The Wave* (c. 1942–44), organic shapes occupy a space anchored at upper right by a rectangle familiar from the paintings of figures. Line still imputes contour, as a sweep of creamy white models the undulant black field that dominates the painting, torquing shape into volume, suggesting hips, pelvises, knees beneath skirts. But change is foretold in the attenuated lines, made using the liner's brush familiar to de Kooning from sign painting, that describe the wavelike curves. Within a year de Kooning's use of the

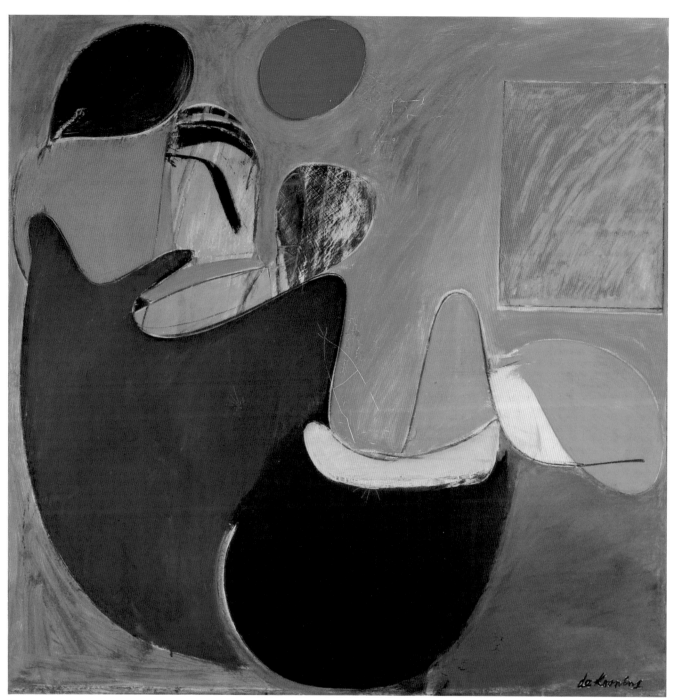

18

18.
The Wave, c. 1942–44.
Oil on fiberboard,
48 × 48 in.
(122 × 122 cm).

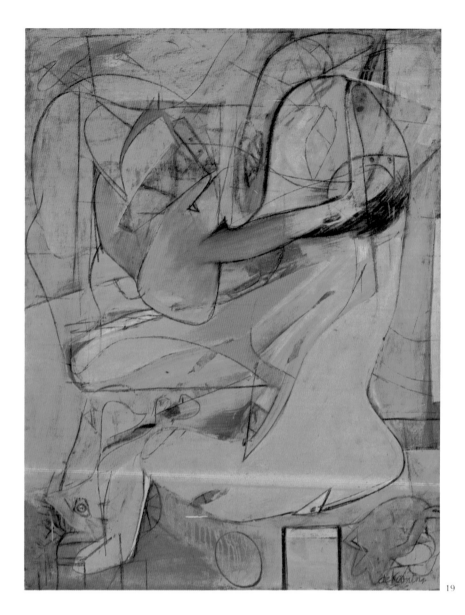

long, slender-bristled brush was flamboyant, as line gathers speed and defies boundaries in *Pink Angels* (1945).

In 1946 de Kooning was invited to paint a backdrop for the dance performance *Labyrinth*, choreographed by Marie Marchowsky and performed in April. With little time and a fee of $50, de Kooning elected to base the *Labyrinth* image on a recently completed painting on paper.[45] He described the small painting to critic Thomas Hess as an image of "the four angels at the gates of Paradise," and to Elaine de Kooning as a "Judgment Day."[46] The four biomorphic shapes, each dominating a quadrant of the composition, might have suggested the hybrid lineage of the minotaur, mythical offspring of Queen Pasiphae and a bull. And the web of line could have seemed a suitable evocation of the thread that Ariadne gave to Theseus to guide him from the labyrinth constructed to contain the untamable half-breed. Roughly a seventeen-foot square, the backdrop was painted with the help of Milton Resnick using paint bought at the hardware store for $5.[47]

One substantial change intervened as de Kooning remade the *Judgment Day* painting into the theatrical set. Just to the right of lower

19.
Pink Angels, 1945.
Oil and charcoal
on canvas,
52 x 40 in.
(132 x 101.5 cm).

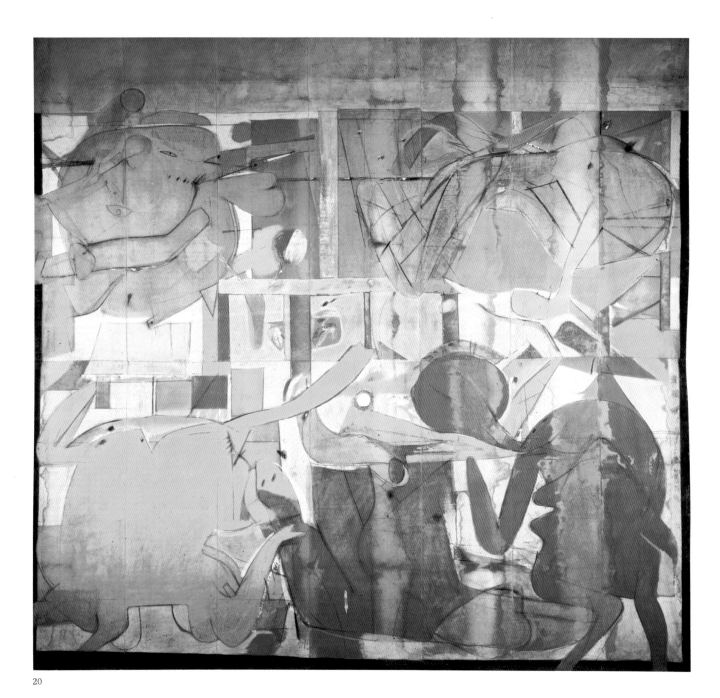

20

20.
Backdrop for Labyrinth,
1946.
Calcimine and
charcoal on canvas,
16 feet 10 in. x 17 feet
(5.13 x 5.18 m).

center a high-heeled shoe materialized, facing off against the satyrlike creature at right. In this apparently whimsical juxtaposition of high heel and hoof, de Kooning succinctly invoked the frightful suggestion at the core of the story of the labyrinth and its inmate—that human civilization is imperiled from within by animal drive. A decade earlier, Picasso had drawn on his own investigations of the minotaur in composing his painterly confrontation with the fascist savagery unleashed on the town of Guernica. In its "subjacent animality," the imagery of the minotaur harbors the anxiety pitilessly voiced in 1929 by Georges Bataille: "There is in every man an animal locked up in a prison, like a convict; and there is a door; and if the door is opened halfway the animal rushes out like the convict finding a way of escape; temporarily the man falls dead and the beast behaves like a beast, without any concern to arouse the dead man's admiration."[48] Although the *Labyrinth* backdrop is genial in effect, the duality embodied in the minotaur must have assumed stark pertinence as de Kooning, with the end of World War II, brooded in his art over the horror that had threatened any optimistic appraisal of humanity. The year that de Kooning pondered *Judgment Day*, the English painter Francis Bacon offered his disconsolate assessment, as *Painting* (1946, acquired in 1948 by the Museum of Modern Art) overlaid with terrifying grandeur the imagery of crucified flesh and butchered meat.

De Kooning embarked on no large paintings of women in 1946 and 1947. He was, however, engrossed in a series of figurative paintings on paper that almost immediately fragmented into abstractions or coalesced into the monumental women that closed the decade. Behind this succession of images on paper are the unmistakable spectres of the wailing women of *Guernica* and the fearsome viragos[49] who stare from the brothel of *Les Demoiselles d'Avignon*. De Kooning was particularly intent on coming to grips with the two righthand *demoiselles*: the one who squats heedlessly and the other who looks on from beyond. The pair may have suggested to him the dichotomy of engagement and detachment that would interest art historian Leo Steinberg in the early conception of the Picasso painting, which began, he proposed in the 1972 essay "The Philosophical Brothel," "not as a charade on the wages of sin, but as an allegory of the involved and the uninvolved in confrontation with the indestructible claims of sex."[50] The two were recast by de

21.
Pablo Picasso.
Les Demoiselles d'Avignon, 1907.
Oil on canvas,
96 x 92 in.
(244 x 233.7 cm).

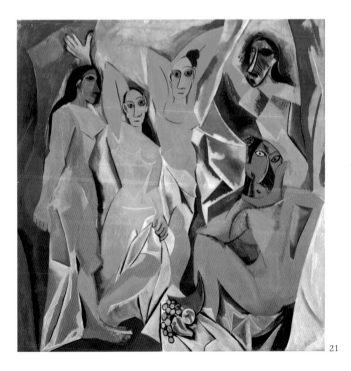

21

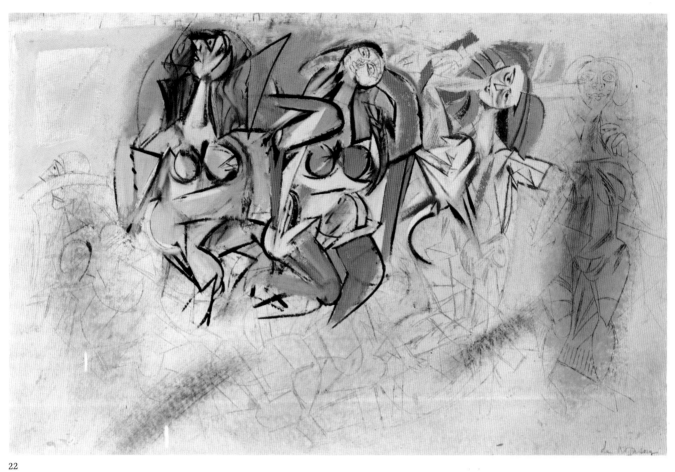

22

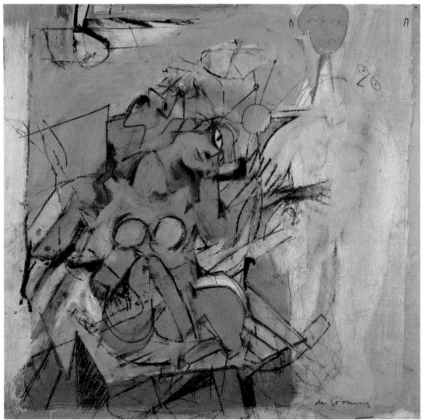

23

22.
*Untitled Study
(Women)*, c. 1948.
Oil on paper,
21 × 32 ⅛ in.
(53.3 × 81.2 cm).

23.
Pink Lady (Study),
c. 1948.
Oil on paper
on fiberboard,
18 ½ × 18 ½ in.
(47 × 47 cm).

33

24

24.
Two Figures,
c. 1946–47.
Oil, colored chalk and
charcoal on paper,
10 ½ × 12 ¼ in.
(26.6 × 31.2 cm).

25.
Pink Angel, 1947.
Oil on paper,
10 × 15 in.
(25.4 × 38 cm).

25

26

26.
Untitled (Three Women), c. 1948.
Oil on paper,
20 x 26 ³⁄₈ in.
(51.7 x 67 cm).

Kooning in *Pink Lady (Study)* (c. 1948) as a frenzied woman perched atop a table or chair and another who stands apart. In *Untitled Study (Women)* (c. 1948) the figures multiply—to match the count of *Les Demoiselles*—vaulting into action, a churning chorus line of three, flanked at right by the one whose gaze is fixed on us trancelike, at left by an ephemeral man on the run.

If Picasso's squatting "prodigy" is "at once frontal and dorsal,"[51] then de Kooning tried out the figure facing forward in *Two Figures* (c. 1946–47) and then backwards in *Pink Angel* (1947). The wild tilted head and hair of the sideways woman at left in both de Kooning works follow Picasso's *Weeping Women* with their sawtooth mouths, and streaming and spiky pitchfork hair. The seated woman at right in *Pink Angel* points toward the figure at the center of *Untitled (Three Women)* (c. 1948). The cleft of buttocks exaggerated, the blur of features troubled by a suggestion of the flicking ears of the bull of *Guernica*, this figure seems scarcely human. She looks instead to be a frantic incarnation of the dying minotaur of *The End of a Monster* (1937), which had closed Picasso's extended meditation on the being doomed by its irreconcilable parentage.[52]

That a woman nearly always surfaced, as de Kooning saw it, even in the most extreme abstraction,[53] is unexpectedly demonstrated in 1948. The brassy-fleshed, righthand figure of *Pink Angel* turns out to be an intermediary: she is the schema for the chalky and liquid strokes that run from the circle just off-center to the lower edge of *Black Friday*. Subsumed into black-and-white impasto, the angel/*demoiselle* becomes a sort of template lost to consciousness, remade into a multivalent image of physicality, flaunting the caress and push of paint. Absorbed into abstraction, the subliminal anatomy accosts the viewer with a force that is at once combative and embracing.

Perhaps the expedition to the hardware store to buy supplies for the *Labyrinth* backdrop jogged de Kooning's imagination. For he soon stocked up on enamel house and sign paints[54] and embarked on the series of black-and-white abstractions, smudged with color, that included *Black Friday* and dominated his first solo exhibition, at Charles Egan Gallery in 1948. More prolific by 1947, de Kooning often painted now on paper, to be mounted on board or canvas, the slick surface accommodating a fluidity of handling. De Kooning might start a painting during these years by drawing something as mundane as his thumb, or by scrawling letters or numbers. "Léger used letters, Picasso used letters— I wasn't so worried about being original."[55] Although the immediacy of such initial moves suggests the automatist tactics of surrealism, de Kooning made no secret of his disinterest in the group of surrealist artists who in the early years of the decade had gathered at Peggy Guggenheim's Art of This Century Gallery.[56] And yet the conscious mind had its limitations. Haphazard beginnings were enlisted by de Kooning not to avoid content but to circumvent the boundedness of intended subject matter and preconceived form.

27

27.
Black Friday, 1948.
Oil and enamel on
pressed wood panel,
49 ¼ × 39 in.
(125 × 99 cm).

37

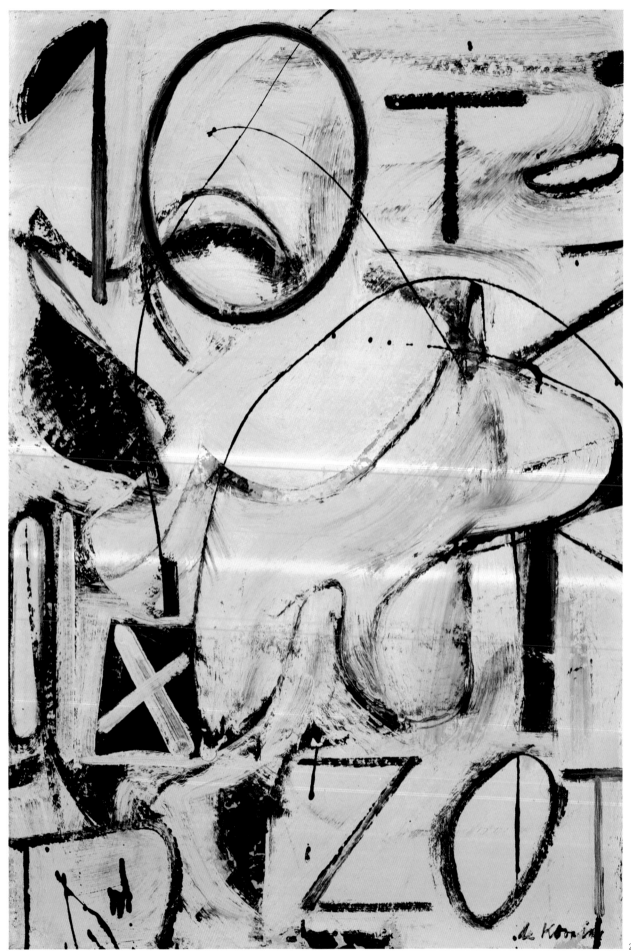

Images, from afar, of impetuous gesture, the black-and-white paintings exposed their careful construction close up, as drips were redoubled in outlines clandestinely presaging the abstract expressionist parodies made in the 1960s by pop artist Roy Lichtenstein. If on this level the paintings incorporated the apparent contradictions of spontaneity and calculation, then too they fended off other clarities. Literally black and white, they might have read as diagrams of figure versus ground—of marks across fields. Yet if in *Zurich* (1947) the black letters of LOT (or is it NOT?) and ZOT (Dutch word for "foolish")[57] are scribed on the evident ground of white, then de Kooning cancels the impression in a summary reversal, a white X painted over an indisputable background black. In this and other paintings of the moment, black advances on white, and white slips ahead of black in a remorseless confounding of figure and ground.

Lines shoot across the surfaces of the black-and-white paintings—even onto the strip frame of *Black Friday*—their arcing forays into space called up short by the sweeps and drips of the paint itself. A brushstroke may shift from line to plane to shape or letter, only to be parried or absorbed by another painterly gesture. De Kooning had since the thirties considered images from a variety of viewpoints, and in the forties began more often to shift the orientation of paintings-in-progress. His unleashing of line ran parallel in time to Pollock's dripping of paint. But de Kooning's work never approximated the overall homogeneousness that led Bacon to observe that Pollock's paintings look like "old lace."[58]

In black and white de Kooning unequivocally undid any residue of illusionistic description. In abstract paintings that are pointedly tenebrist in palette and somatic in allusion, de Kooning flaunts the conventions of Western picture-making since the Renaissance, as he reiterates the renunciations fundamental to his paintings of women of 1940–46. Each intimation of light and shadow, perspectival space, foreshortened form is leveled in the end, reclaimed by a painting surface that is aggressive in its materiality. Following the directives of sensuous intuition and intelligible intention, the paintings evince the conviction that form and idea, like body and mind, are inextricable. Like an archaeologist of painterly process, the viewer searches—passage by passage—these works that enact, rather than portray, their content. Weighing the issues of "sensation and meaning" in the work of de Kooning, Barnett Newman turned, compellingly, to Paul Cézanne: "His was a life spent trying to transmute illusion, the illusion of the old masters, into the reality of sensation."[59]

The titles of the works at Egan veered from the impromptu and oddly descriptive (*Zurich*; *Valentine*, 1947; *Mailbox*, 1948; *Painting*, 1948) to the resounding and literary (*Black Friday*; *Orestes*, 1947; and *Light in August*, c. 1946, after the 1932 Faulkner novel).[60] Like de Kooning's titles, the paintings in 1946–48 moved from the cues of physical fact and painterly facture to metaphysical speculation and mythic

28.
Zurich, 1947.
Oil and enamel on paper, mounted on fiberboard,
36 × 24 1/8 in.
(91.5 × 61.2 cm).

39

29.
Orestes, 1947.
Enamel on paper
mounted
on plywood,
24 ¹/₈ × 36 ¹/₈ in.
(61.2 × 91.7 cm).

30.
Warehouse Manikins,
1949.
Oil and enamel on
buff paper, mounted
on cardboard,
24 ¹/₄ × 34 ⁵/₈ in.
(61.5 × 88 cm).

31

31.
Painting, 1948.
Enamel and oil
on canvas,
$42\,^{5}/_{8} \times 56\,^{1}/_{8}$ in.
(108.2 × 142.4 cm).

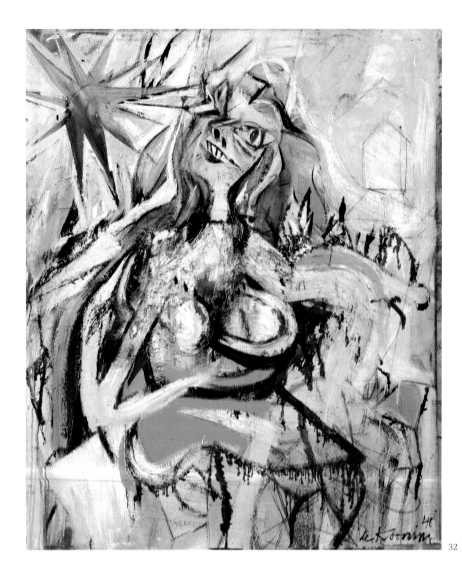

invocation. In *Black Friday*, *Orestes*, and *Light in August*, de Kooning summoned up the epic scale of human action ensnared by inexorable and discordant forces that was fundamental to each tragic story. In *ARTnews*, Renée Arb declared that "his subject seems to be the crucial intensity of the creative process itself." Clement Greenberg hailed "this magnificent first show."[61] And the largest of the works, *Painting*, was purchased in October by the Museum of Modern Art. De Kooning sure-ly was a proponent of abstraction to be reckoned with.

Yet the human figure remained for him inescapable. *Orestes* and *Painting*, like *Black Friday*, pulse with the forms of the body, however much abstracted. Mouths grin from *Mailbox*. And the ghost of a model in a bathing suit ad, transferred from a sheet of newspaper laid across the wet surface of *Attic* (1949) to slow its drying,[62] comes into focus at lower left. If it showed up by chance, then it remained by design: it is a lure. Like the counterfeit pentimenti of the late thirties and early forties, the unexpected hint of advertising imagery pulls the viewer close. Retracing the elusive passage, the observer is drawn into the surround of pigment that betrays the jabbing, slide, and scrape of the broad brush, liner's brush, palette knife.

32.
Woman, 1948.
Oil and enamel
on fiberboard,
53 ⅝ × 44 ⅝ in.
(136.2 × 113.3 cm).

33.
Woman, 1949.
Oil, enamel, and
charcoal on canvas,
60 × 47 ⅞ in.
(152.4 × 121.5 cm).

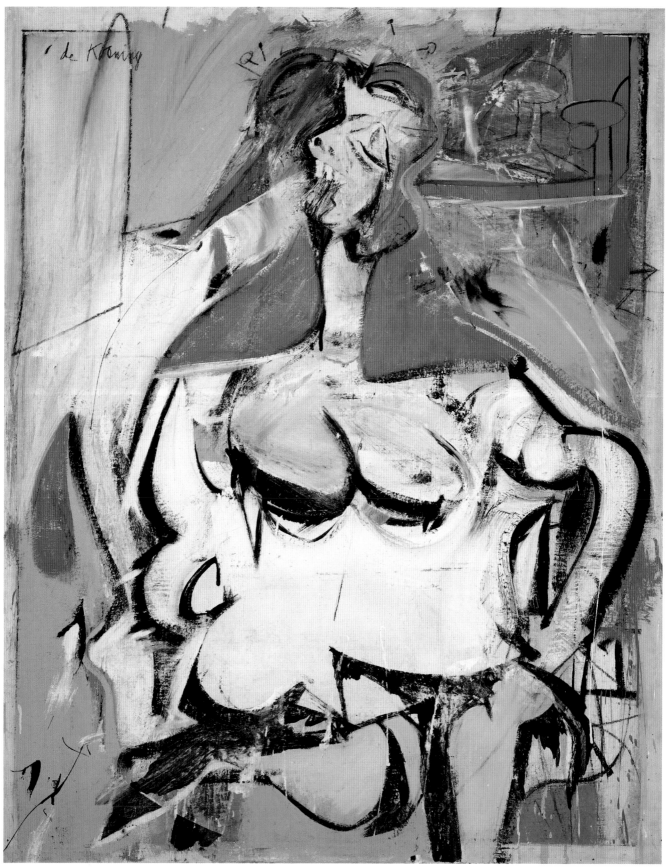

33

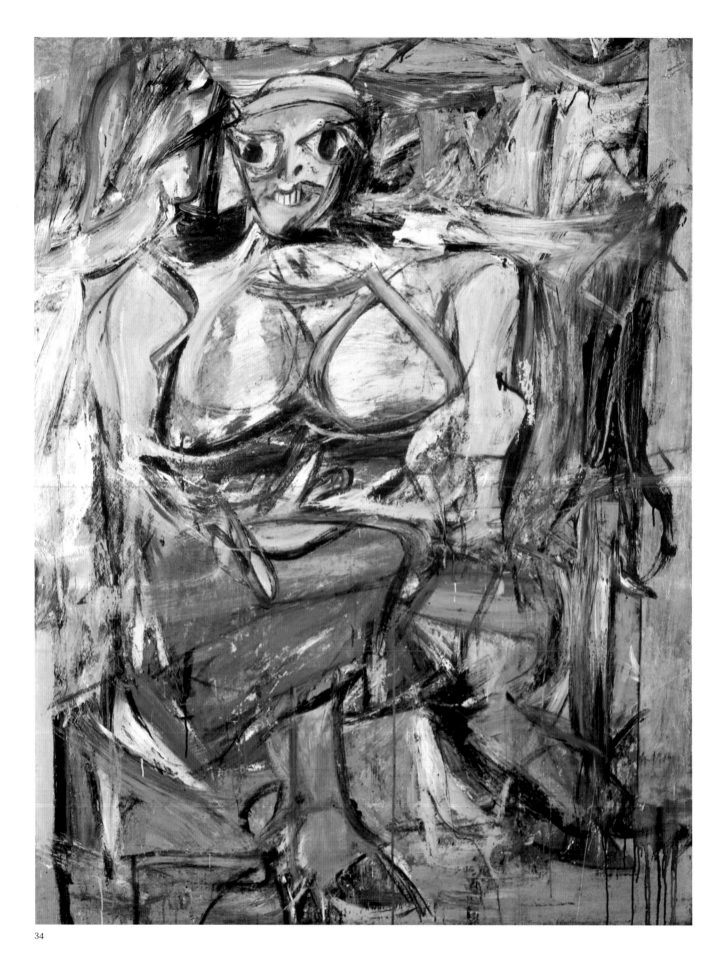

34

The unquiet and conflicted marks that disrupt legible space and cohesive form in the black-and-white abstractions rage against the garish, nearly life-size women whom they fabricate and cleave beginning again in 1948. The unassuming seated women who opened the forties have been brushed aside, as convulsive dancers rampage toward the tempestuous *Woman I* (1950–52). The house shape at upper left in *Black Friday* is mirrored at upper right in *Woman* (1948), paired now with a cartoonlike sign of an explosion. Like the rudimentary house, the figure making a comeback will apparently have to be rethought, coalescing only to lose her edge in a black wash at lower right and a mean cut to the face at left. No doubt it seemed untenable to reconcile the human image with the reeling space that had been devised in black and white. But "if you take the attitude that it is not possible to do something, you have to prove it by doing it."[63] The liquifying contours of *Woman* (1948) are succeeded by the crisp sweeping black outlines of *Woman* (1949) a year later. The momentum of de Kooning's lashing line and swiped impasto has no antecedent. It looks instead to the future. De Kooning's women have by now taken charge, facing us off one by one, one-on-one.

The last men of the decade to survive in paint were beleaguered. One (c. 1947) stood wide-eyed and frozen like a manikin next to an agitated feminine cohort. Another (1947) wore manikin features and laceless shoes. And there was the terror-struck man in retreat of *Untitled Study (Women)*. As the new decade opened, the few remaining men appeared as protagonists in pencil crucifixion images.

· · ·

Throughout the forties the New York painters were emboldened by a new dependability of exhibitions, occasional sales, and critical recognition. In a 1946 *New Yorker* review of Hans Hofmann's paintings, Robert Coates introduced the name "Abstract Expressionism" to identify, more appreciatively, "what some people call the spatter-and-daub school of painting."[64] *ARTnews* was consistent in its attention under the editorship of Hess, beginning in 1948; that year Elaine de Kooning became an editorial associate, writing with insight about many of the emerging artists. Her career as a painter was also unfolding, and work by both de Koonings was included in the 1949 exhibition *Artists: Man and Wife* opening the second season at Sidney Janis Gallery. A succession of periodicals gave voice to artists and writers. *Orestes* was reproduced in *Tiger's Eye*, which was published from 1947 through 1949. De Kooning's talk "The Renaissance and Order" was included in 1951 in *trans/formation*, which was issued until 1952.

While many of the refugee artists returned to Europe after the war, the New Yorkers were not discouraged, establishing in 1949 the sociably named Club at 39 East Eighth Street. "We always wanted not exactly to start a club but to have a loft and for years I had it in mind,"

34.
Woman I, 1950–52.
Oil on canvas,
75 7/8 x 58 in.
(192.7 x 147.3 cm).

45

de Kooning reflected. "The Greeks and Italians each have their own social clubs along Eighth Avenue. We didn't want to have anything to do with art. We just wanted to get a loft, instead of sitting in those god-damned cafeterias. One night we decided to do it—we got up twenty charter members who each gave ten dollars and found a place on Eighth Street. We would go there at night, have coffee, a few drinks, chew the rag. We tried but couldn't get a name so we called it the Club."[65]

Two doors away, David Hare, Rothko, William Baziotes, Motherwell, and Newman had set up the Subjects of the Artist School in 1948. Outlasting the demise in spring 1949 of the short-lived School, Friday evening lectures were continued under the name Studio 35 after the 35 East Eighth Street address. Beyond the core of painters and sculptors, the roster of speakers and participants in the activities of the Club, the School and Studio 35 included writers, philosophers, and composers, among them Hess, Harold Rosenberg, Joseph Campbell, Hannah Arendt, and William Barrett, whose articles in *Partisan Review* and book *Irrational Man* (1958) would introduce a broad field of readers to existentialism. Concerned that abstraction might be mistaken for vacuousness or for mere decoration, artists and writers aligned the banishment of discernible imagery with a push toward momentous content and visceral immediacy. Determined to elude the vice-grip of language, de Kooning contended, in the course of a Studio 35 roundtable probing meaning and titling, that "if an artist can always title his pictures, that means he is not always very clear."[66]

The de Koonings spent the summer of 1948 at Black Mountain College in Asheville, North Carolina. Flush with his success at Egan, Willem had been invited by Josef Albers to join a faculty that included John Cage, Merce Cunningham, Buckminster Fuller, and Richard Lippold. During this rural sojourn, "Elaine was reading Bill passages from Kierkegaard," Patricia Passlof remembered.[67] The idyll was broken by word of Gorky's suicide. Protective of his friend's spirit, de Kooning avoided maudlin analysis. "Gorky was a peasant. He was very strong, so when his body failed him, he removed it."[68] Devoted, he wrote to *ARTnews*: "When, about fifteen years ago, I walked into Arshile's studio for the first time, the atmosphere was so beautiful that I got a little dizzy and when I came to, I was bright enough to take the hint immediately. . . . I am glad that it is about impossible to get away from his powerful influence. As long as I keep it with myself I'll be doing all right."[69]

In the fall, after the stay in North Carolina, de Kooning visited the exhibition of Alberto Giacometti's work, with a catalogue essay by Jean-Paul Sartre, at Pierre Matisse Gallery. It "knocked him out," Elaine de Kooning remembered, "it was crucial; it looked like the work of a civilization—not one man."[70] De Kooning's February 1949 talk, "A Desperate View," at the Subjects of the Artist School contemplated action in a world tinged by Kierkegaard's *Fear and Trembling*: "My interest in desperation lies only in that sometimes I find myself having become

desperate. . . . I can see of course that, in the abstract, thinking and all activity is rather desperate. . . . In Genesis, it is said that in the beginning was the void and God acted upon it. For an artist that is clear enough. . . . One is utterly lost in space forever. You can float in it, fly in it, suspend in it and today, it seems, to tremble in it is maybe the best or anyhow very fashionable."[71] No doubt one source of insight into the writings of Kierkegaard and Sartre was Barrett, whose discussions de Kooning followed with rapt attention. That art was of utmost importance in the face of an arguably indifferent universe was articulated by one after another of the abstract expressionists. "The attitude that nature is chaotic and that the artist puts order into it is a very absurd point of view, I think," de Kooning reasoned in "The Renaissance and Order" in 1950. "All that we can hope for is to put some order into ourselves. When a man ploughs his field at the right time, it means just that. Insofar as we understand the universe—if it can be understood— our doings must have some desire for order in them; but from the point of view of the universe, they must be very grotesque."[72] Or, as Barrett read Sartre: "Man's existence is absurd in the midst of a cosmos that knows him not; the only meaning he can give himself is through the free project that he launches out of his own nothingness."[73] "The Renaissance and Order" was read to the group at Studio 35, twice, by Motherwell after de Kooning suddenly became concerned about his Dutch accent.[74]

If the cosmos could not be made responsive, then at least the institutions devised to nurture culture perhaps might be. A May 1950 "open letter" to the president of the Metropolitan Museum of Art—signed by eighteen painters, including de Kooning, and ten sculptors—protested the museum's lack of commitment to "advanced art": "For roughly a hundred years, only advanced art has made any consequential contribution to civilization." *Life* magazine detected in this a newsworthy image. In the photograph of the painters published in the January 15, 1951 issue, the fourteen men and one woman (Hedda Sterne, positioned to tower over the rest) who had—together with three colleagues absent from the photo session—been dubbed the Irascible Eighteen in the May 23 *Herald Tribune*, look distinguished, respectably dressed "like bankers" for the occasion at the behest of Newman.[75]

"Advanced art" had made headway in more forward-looking circles. *Mailbox* and *Attic* were included in the 1948 and 1949 Whitney Annuals, respectively. *Excavation* (1950) and three other abstractions were shipped to the 1950 Venice Biennale, presented together with works by Pollock, Gorky, Lee Gatch, Hyman Bloom, and Rico Lebrun around a John Marin retrospective. "In America," Alfred Barr explained of Gorky, de Kooning, and Pollock, "several names have been used to describe this predominant vanguard: 'symbolic abstraction,' 'abstract expressionism,' 'subjectivism,' 'abstract surrealism.'"[76] Serge Guilbaut has argued that it was not simply good luck, tenacity, and talent that brought acclaim. Rather, "the idea of modern art" fitted purposes that

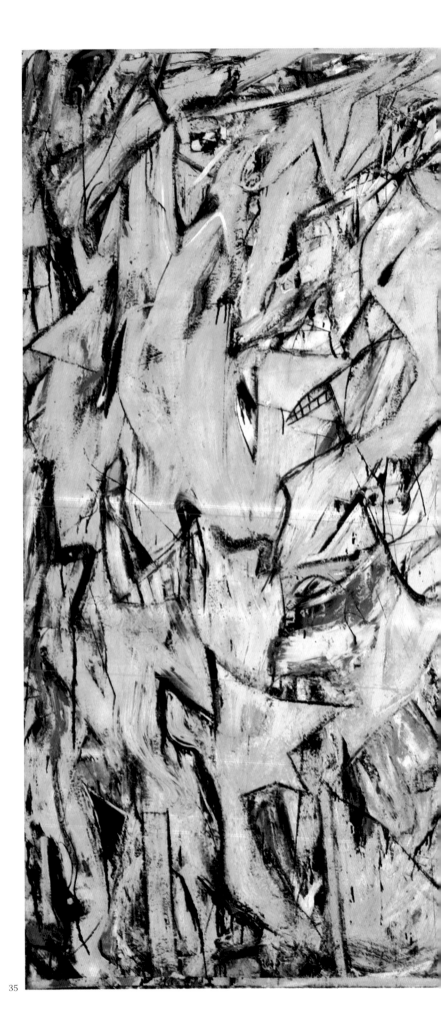

35.
Excavation, 1950.
Oil on canvas,
80 ¹/₈ x 100 ¹/₈ in.
(203.5 x 254.3 cm).

35

48

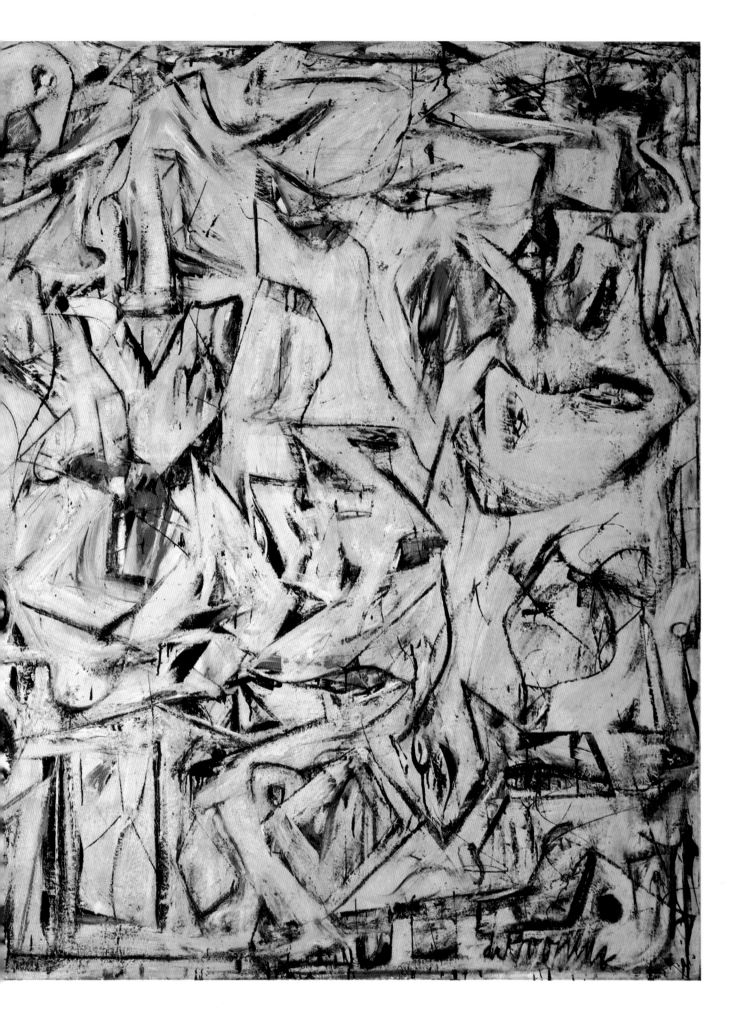

were decidedly extra-artistic. Rugged in its individualism and open-ended in its abstraction, abstract expressionism was, the case goes, well-suited to the propagandistic agendas of U.S. policy during the Cold War—an apt embodiment of freedom, tailor-made for cultural export. Whatever the intertwining of promotion and propaganda, the "triumph of American painting" celebrated in 1970 by Irving Sandler was under way by 1950.[77]

De Kooning commuted to New Haven to teach at Yale during the fall of 1950. Returned from Venice, *Excavation* was included in *Abstract Painting and Sculpture in America,* which opened in January at the Museum of Modern Art. If the painting has the presence of a cliff face, then it is a geology read by a rock-climber. The 8½-foot-wide work—which de Kooning worried might be too big—is read inch by inch, mark by mark. The "nameless malaise" felt by Katharine Kuh derives in part from the "'impossible' transitions" detected by Hess. Abrupt disjunctions were cultivated as de Kooning here and else-where, beginning in the late forties, took to placing drawings or sheets of paper directly on the painting surface, painting over and around them, then removing them.[78] Merciless in his command and revision of vigorous brushwork, de Kooning dramatized his methods in *Collage* (1950), its gestures flagrantly pieced together with thumbtacks. Invited to speak in connection with the Museum of Modern Art exhibition, de Kooning enlisted Andrew Carnduff Ritchie to read his talk. "Some painters," de Kooning asserted, "including myself, . . . have found that painting—any kind of painting, any style of painting—to be painting at all, in fact—is a way of living today, a style of living."[79]

Egan presented a second one-person show of abstractions in April 1951. Hess wrote incisively that "the pictures of Willem de Kooning . . . have an air of authority-in-crisis perhaps unique in con-temporary expression. . . . De Kooning's personal solution involves making the crisis itself the hero of the painting."[80] De Kooning, Kline, and Resnick hatched the idea of the Ninth Street show: in May works by some sixty artists were installed by Leo Castelli in a former furni-ture store at 60 East Ninth Street. A crowd flocked to the opening illu-minated by klieg lights.[81] And that fall *Excavation* was awarded the Logan purchase prize at the Art Institute of Chicago's Annual.

With an admiring audience and a bit more cash on hand, the artists moved into more visible gathering places. "After a while we only used the Club on Friday and Saturday nights. The rest of the time we'd all go to the Cedar Bar as we were drinking more then." Pollock and Krasner had settled in Springs in 1945, the year of their marriage. But when Pollock was in the city, he often joined the group at the Cedar Tavern. Pollock "was suspicious of any intellectual talk. . . . But he was smart though—oh boy—because when he was half-loaded, that in-between period, he was good, very good, very provocative."[82] The cast-ing of Pollock as a sort of film noir persona—a notion recently eluci-dated by Michael Leja[83]—in a story that ended horribly in 1956 on a

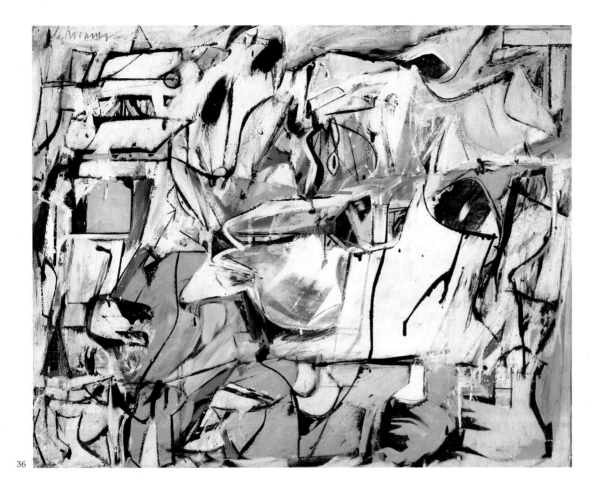

36

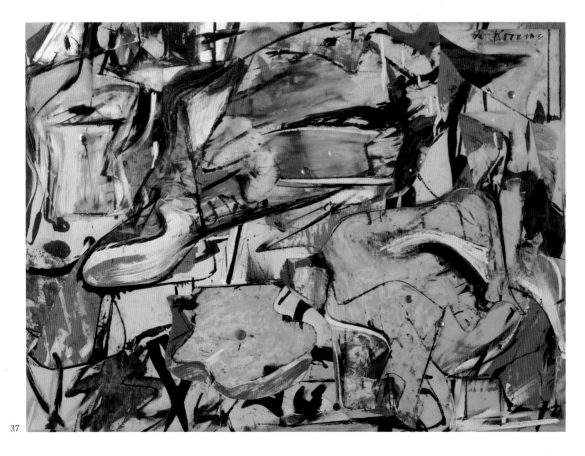

37

36.
Asheville, 1949.
Oil on illustration
board,
25 ½ x 32 in.
(64.7 x 81.2 cm).

37.
Collage, 1950.
Oil, enamel, and
metal (thumbtacks) on
cut papers,
22 x 30 in.
(56 x 76.2 cm).

curve in a road in Springs, had begun by the start of the Cedar Tavern days. Krasner had expected that Springs might steady Pollock's volatile temperament: this eastern end of Long Island around the Hamptons had for some years proffered escape for artists and writers from Manhattan. The summer of 1951, and the next two, the de Koonings spent as house guests of the Castellis in East Hampton.

In 1952 Harold Rosenberg formulated the notion of the impassioned "action painter." Echoing de Kooning's remarks at the Museum of Modern Art, Rosenberg proposed that "at a certain moment the canvas began to appear to one American painter after another as an arena in which to act. . . . A painting that is an act is inseparable from the biography of the artist. . . . The new painting has broken down every distinction between art and life." Hess, who published "The American Action Painters" in *ARTnews*, would later downplay the essay's role.[84] But the romantic image of the inspired artist, undeterred by the senseless drift and inexplicable brutality of existence, took hold. Robert Rauschenberg promptly confronted the existentialist heroics embedded in the rhetoric of action painting, as he laboriously undid the apparently impetuous marks of the older master in *Erased de Kooning Drawing* of 1953.[85]

• • •

By 1950 de Kooning was engaged in a rapid-fire succession of drawings and paintings of women. In sundresses, bathing suits, seated or standing, the women of this moment are beguiling and bedeviling. The cue of the bathing beauty of *Attic* snapped into living color as the women evolved toward their larger-than-life sorority of 1950–53.[86] De Kooning began to clip mouths from magazine ads, affixing these orifices to works in progress. A sort of reality principle, the gleaming teeth and ruby lips called up the coup pulled off by an advertising industry brazenly undertaking to do "what no artistic or literary genre could: making the private body a subject of everyday public discourse, especially visual discourse."[87] The seductive mouths must have been irresistible centers to the tumult of painterly action that threatened the integrity of the figure at every turn. On glossy magazine stock, the disembodied lipsticked smiles were in their own way inviolate, impenetrable to the battering advances of paint. In the end the only magazine mouth—from a Camel cigarette-ad T-zone—to preside in a finished painting of these years was in the diminutive *Woman* of 1950. Her schematic pelvis suggested by Cycladic idols, the eye-breasts were triggered by Picasso's *The Dance* (1925).[88] But with the small detail of the smile, extracted from the T-zone mechanically outlined across the cigarette-ad model's mouth and throat, de Kooning ventured across the breach between high art and low. "De Kooning's flirtation with the tabloid Muse who emerged from the sea of his exquisite gestures demonstrated," Robert Storr ruminated four decades later, "that in the

38.
Woman, 1950.
Oil, enamel, and
pasted paper
on paper,
14 ⅝ x 11 ⅝ in.
(37.2 x 29.5 cm).

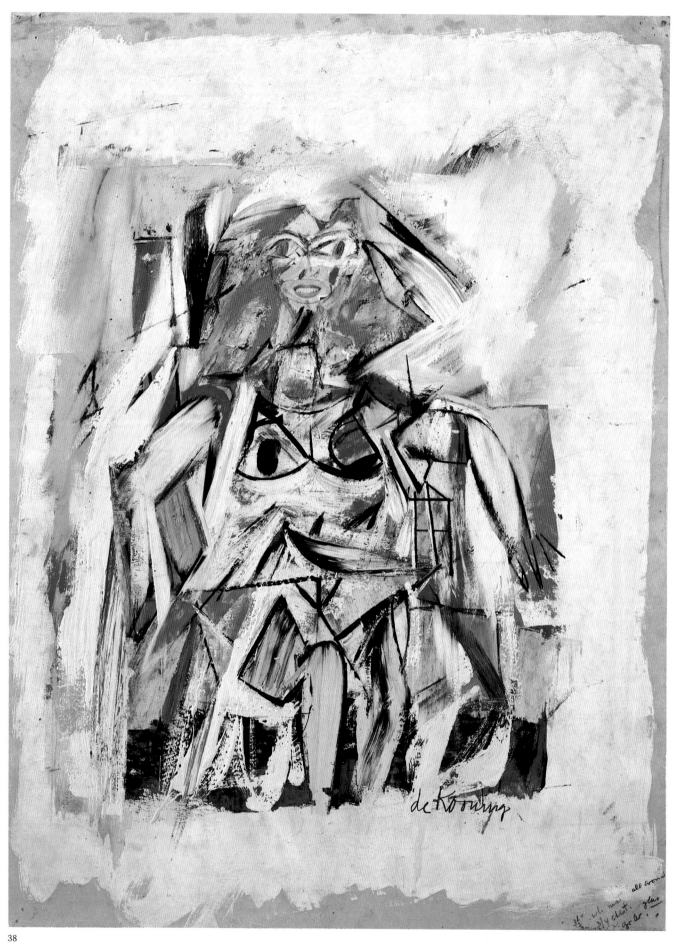

38

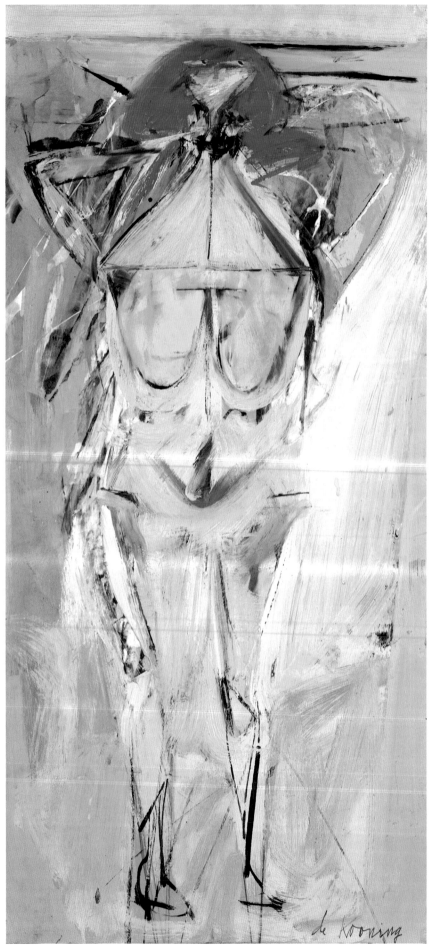

39.
Figure in Landscape,
No. 2, 1951.
Oil and pencil on
paper, mounted
on fiberboard,
33 x 15 ½ in.
(83.8 x 39.4 cm).

39

modern era automatism is as likely to conjure up a fleshy screen idol as a spare Jungian archetype."[89]

Wild-eyed, face exalted, the expansive *Woman I* (1950–52) bursts forth from a field of brushstrokes that have widened and proliferated, barely acknowledging the difference between figure and surround. Except for a sinuous curve here and there, the slender whiplash[90] line of 1946–49 has been lost in the barrage of slapping and cajoling strokes of color. A photograph by Aaron Siskind of crumpled paper evidently seemed an apt model of a space at once complex and finite. As de Kooning wrestled the Amazonian *Woman I* into place, he kept the 1950 image, entitled *New York*, in the studio like a talisman.[91] And, too, there were exhibitions that proved pertinent: Vincent van Gogh at the Metropolitan Museum in 1949–50; Chaim Soutine at the Museum of Modern Art, opening in October 1950; Jean Dubuffet at Pierre Matisse Gallery in 1950, 1951, and 1952. "I've always been crazy about Soutine. . . . Maybe it's the lushness of the paint. He builds up a surface that looks like a material, like a substance. There's a kind of transfiguration, a certain fleshiness, in his work."[92] The relentless process that produced the final *Woman I* took two years, as de Kooning painted out woman after woman before reaching a stalemate he could not get beyond. Stuck, de Kooning put the painting out of sight. A visit by art historian Meyer Schapiro led to the conclusion that the work should stand as is,[93] and de Kooning moved on to the Valkyries that are *Woman II* through *Woman VI*.

The statuesque *Woman and Bicycle* (1952–53) closes the series announced by *Woman* (1950). In the grin that doubles the voracious smile and mimics a necklace of pearls, de Kooning overlays the surrealist vagina dentate across a Freudian "displacement upward."[94] It was here, as Freud saw it, in this region of mouth and throat that his young patient Dora's hysteria had found somatic expression: a transposed field of sexuality that she rebuffed with attacks of repressive laryngitis and coughing. De Kooning had no interest in Freud: "Freud messed up all of modern thought, because he made formulas out of it. There were other men such as Dostoevsky who knew much more and could go anywhere."[95] But the Camel-ad men presumably did have an interest in the popular implications of the psychoanalyst's theories, shamelessly pitching their product at "your 'T-zone'!"

While the 1948 exhibition of black-and-white paintings had established de Kooning's preeminence as an abstract painter, the 1953 *Paintings on the Theme of the Woman* at Sidney Janis Gallery confirmed that the artist was a renegade. Hubert Crehan advised that "these paintings of the *Woman* are, in the strictest sense, monstrous—half symbol, half fact."[96] Sidney Geist pondered de Kooning's paintings on "a theme that has been plaguing him for two years": "In a gesture that parallels a sexual act, he has vented himself with violence on the canvas which is the body of this woman, in what is a desperate effort to find an image, to make an equivalent for the heat, the feel, the smell, the desires and

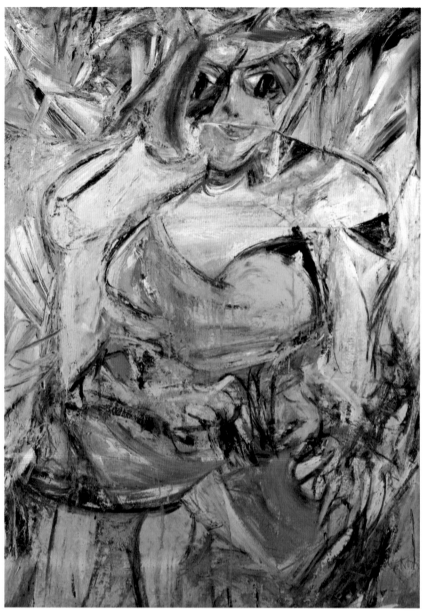

40

40.
Woman II, 1952.
Oil on canvas,
59 × 43 in.
(150 × 109.2 cm).

41.
Woman and Bicycle,
1952–53.
Oil on canvas,
76 ½ × 49 in.
(194.3 × 124.5 cm).

surprises of life. . . . He has gone too far, but that is the only place to go."[97] "I know of one painter who has been unable to paint since he saw the paintings," James Fitzsimmons reported in *Arts and Architecture*, "and I have heard at least a dozen others describe them as 'profoundly disturbing' and call *The Woman* 'a horror' and 'an evil muse'—proof, I think, that the work is of more than personal significance. I suspect that an artist who has the power to move people this deeply may be a great artist."[98] "Certain artists and critics attacked me for painting the *Women*," de Kooning noted in 1960, "but I felt that this was their problem, not mine. I don't really feel like a non-objective painter at all. . . . I look at them now and they seem vociferous and ferocious. I think it had to do with the idea of the idol, the oracle, and above all the hilariousness of it. I do think that if I don't look upon life that way, I won't know how to keep on being around."[99] *Woman I* was bought by the

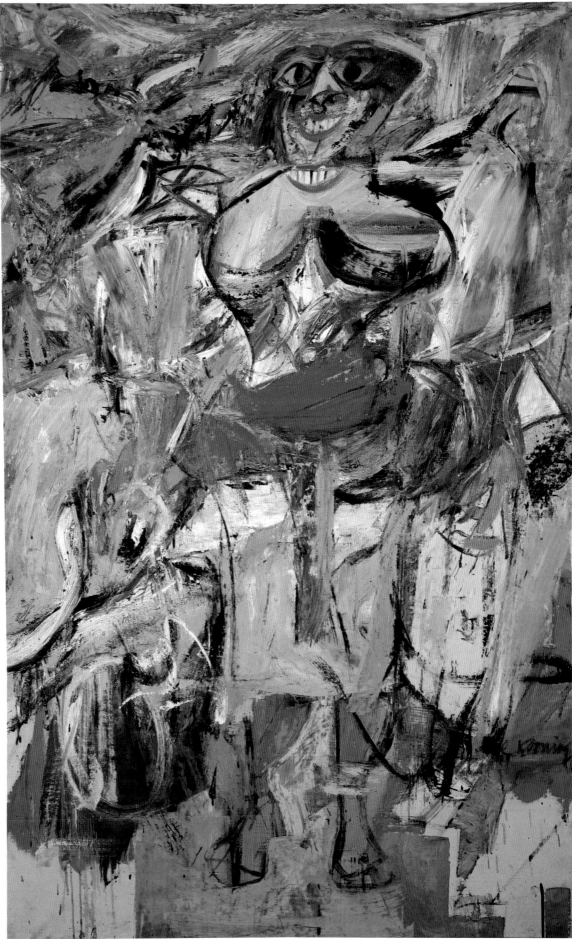

41

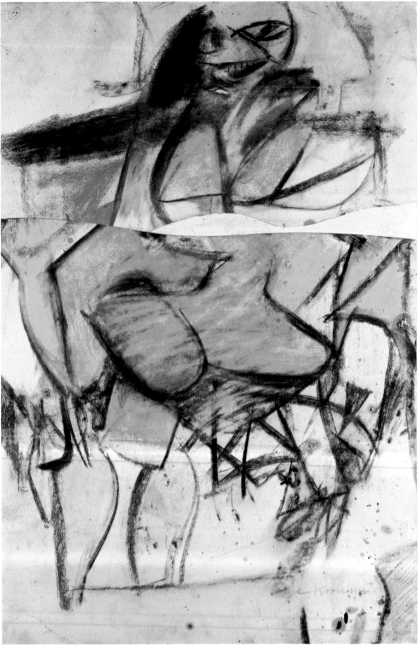

42

Museum of Modern Art, and ten days after the Janis show closed, de Kooning's first retrospective opened in Boston at the School of the Museum of Fine Arts.

Between 1953 and 1955 the women appeared in zany duos and occasional trios more convivial than the tense pairs of *Pink Angel* or *Pink Lady (Study)*. If the Giuseppe de Santis film *Bitter Rice* (1949) was important for *Excavation*—"the wet fields with peasants spading up and into the rich loam"—then the picture of "beauties standing knee-deep in their own reflections"[100] in the alluvial waters perhaps informed de Kooning's images of pert seaside holidaymakers. Radiant, they galavant like the startling matrons, hookers, and spinsters of Jane Bowles's *Two Serious Ladies* (1943), whose erratic escapades and rampant non sequiturs captivated de Kooning. Beaming, they hail from the movies, the news, and the billboards. *Marilyn Monroe* (1954) was painted the year the screen star made

42.
Woman, 1952.
Charcoal and pastel
on paper,
29 1/8 × 19 5/8 in.
(74 × 49.8 cm).

58

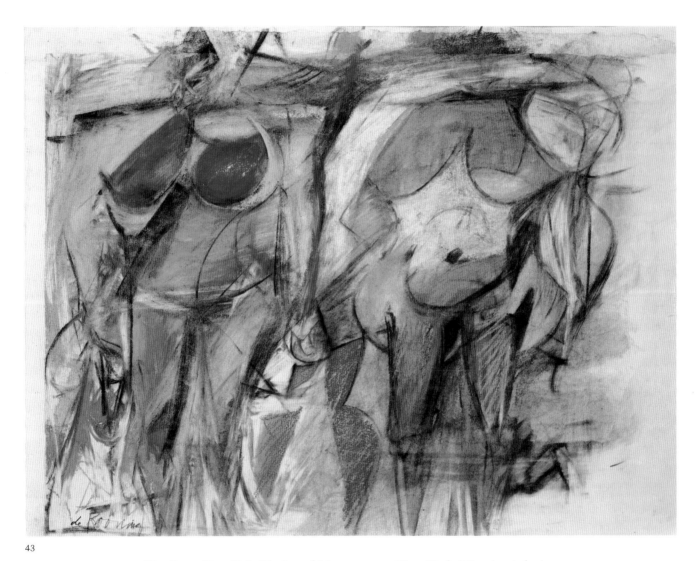

43

The Seven Year Itch. Photos of Monroe on a New York City street during the filming of the movie, her skirt lofted by the breeze of an onrushing subway beneath the sidewalk grating, immediately entered the collective imagination even as the episode proved the last straw in her marriage to Joe DiMaggio. The scene hit its apogee of public visibility with the display of a blowup some fifty feet high on the facade of a New York theater during the movie's opening run.[101] The December before, *Playboy* magazine had first hit the stands, bolstered by the image of Marilyn "with," as she put it, "nothing on but the radio."[102]

"Certainly I am nearer to becoming a saint," Bowles's Miss Goering reports at the end of *Two Serious Ladies*, "but is it possible that a part of me hidden from my sight is piling sin upon sin . . . ? "[103] De Kooning was interested in the question and had contemplated saintliness and sin as he read Faulkner's *Requiem for a Nun* (1950) and *Light*

43.
Torsos, Two Women,
c. 1952–53.
Pastel on paper,
18 7/8 × 24 in.
(48 × 61 cm).

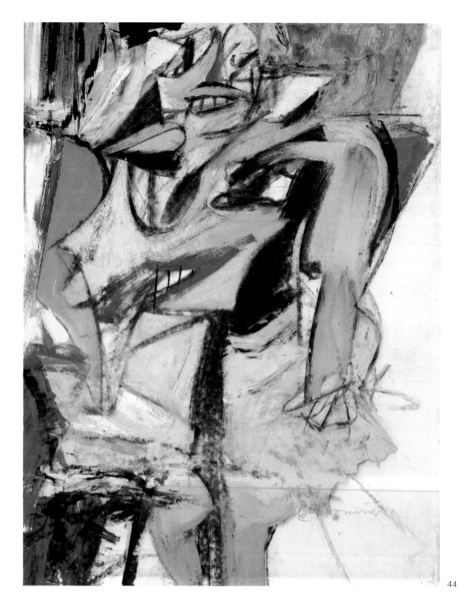

44

in August, Dostoevsky's *Crime and Punishment* (1866), Gertrude Stein's *Four Saints in Three Acts* (1929).[104] While Stein's language was irrational, even unfathomable, the rhythmic repetitions and insistent discordances were inescapably visceral in effect. "The more a text exploits the multiple resonances of a single word," Lisa Ruddick has proposed of Stein, "the less one can image an adequate paraphrase. In order to reach the meaning of a passage, the reader must keep crossing through the material word."[105] In Stein's writing the textual layering and mesmerizing momentum of sound overtake narration; in de Kooning's art, palpable paint engulfs description.

• • •

44.
Woman, 1953.
Oil and charcoal on
paper, mounted
on canvas,
25 ⅝ x 19 ⅝ in.
(65 x 49.8 cm).

During the summer of 1954 the de Koonings, who by now led lives relatively independent of each other, joined up with Franz Kline, Ludwig Sander, and Nancy Ward to rent the Red House in Bridgehampton, on the road from Manhattan to East Hampton. The Venice Biennale opened in June with more than twenty paintings by Willem in the U.S. pavilion,

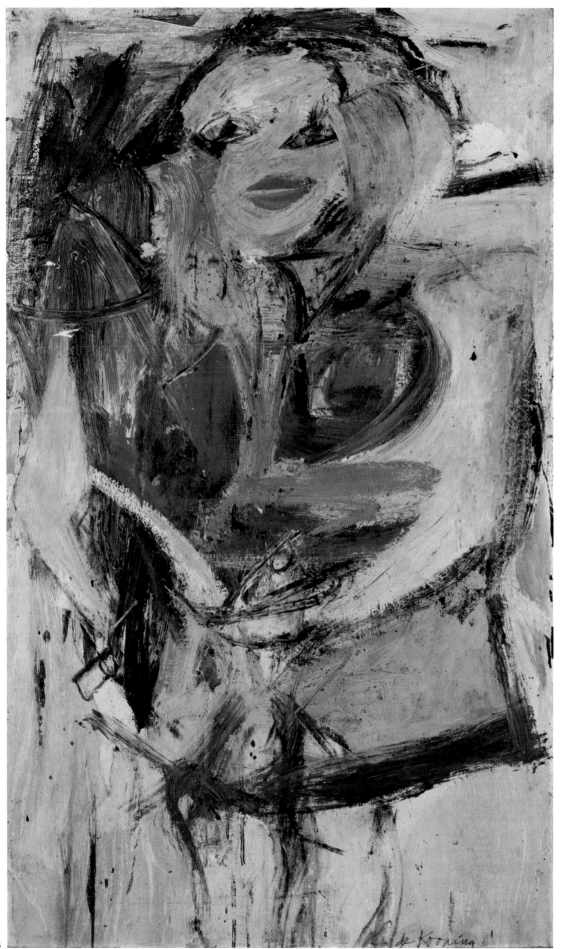

45

45.
Marilyn Monroe,
1954.
Oil on canvas,
50 x 30 in.
(127 x 76.2 cm).

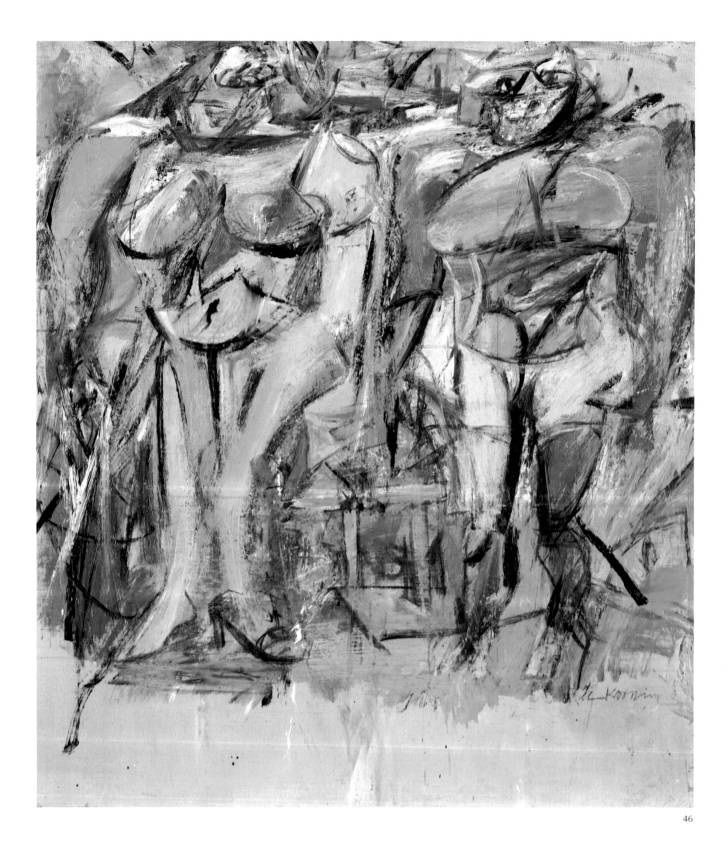

46

46.
*Two Women in the
Country*, 1954.
Oil, enamel, and char-
coal on canvas,
46 ¹/₈ × 40 ³/₄ in.
(117 × 103.5 cm).

along with the work of four other artists. Over the next year, the female image barely held its own amidst the lush strokes of color that inundate such paintings as *Woman as a Landscape* (1954–55). The abstractions that followed in force take their cue from the congested contours of the city. The names herald their Manhattan origin—*Backyard on 10th Street*, *Gotham News*—or signal moments and events—*The Time of the Fire*, *February*, *Saturday Night*, *Easter Monday*. In January 1956 Johanna Lisabeth was born to de Kooning and Joan Ward. That year the separation of Elaine and Willem was made official.

Passages are troweled, scraped, dripped, rubbed, brushed, blocked, knifed, and elided by the mid-fifties. The effect, apparent product of untrammeled immediacy, seemed to Brian O'Doherty instead to be a record of time. In a 1968 essay, he considered *Gotham News* (1955). "It has been worked over and over. Sometimes parts survive from a picture or pictures that have gone under. . . . The picture is thus full of discontinuities between remembering (keeping something from the past) and forgetting (painting over it). But this process 'on top of' is more than matched by 'side by side' evolutions. . . . There may be five months between top and bottom, a year between left and right, instants between somewhere else and somewhere else. There is a conjunction of different times (rather than disjunctions of space) trying to describe the picture."[106] The ruptures of continuity, as O'Doherty saw it, traced the accumulated forces and temporal strata of de Kooning's painterly campaigns.

To prolong the malleability of the oil paint, de Kooning continued sometimes to spread sheets of newspaper across the paintings overnight. Offset headlines and advertisements shade passages of white in *Gotham News* and *Easter Monday* (1955–56). As though to confirm that these seemingly random intrusions were thoroughly intended, de Kooning selected pages pertinent to the imagery of Easter for the painting *Easter Monday*. Commanding from afar, *Easter Monday* in its overall scale imposes a distance of ten or twenty feet on the viewer. Engrossing close up, the painting draws in any but the most incurious of observers. Tight to the surface—its movie and appliance sale notices formulating a pop cultural subtext to the metatext of crucifixion and resurrection—the viewer is immersed in the physical fabric of the painting. The autographic claim staked by the signature at left is mocked at lower right by some newspaper-transfer Goliath of the movies. Wielding his javelins with swaggering grandiosity, he pierces nothing so pointedly as the myth of the action painter. The work purportedly was named after the actual, or perhaps anticipated day of its completion, just in time for inclusion, with paint still wet, in the one-person exhibition at Sidney Janis Gallery opening April 2, the day after Easter Sunday that year.[107] Whatever the proddings of exhibition schedules, however suggestive the tragicomic collisions of ads and Christian admonitions, the title *Easter Monday* concludes a portentous-sounding cycle initiated eight years before with *Black Friday*.

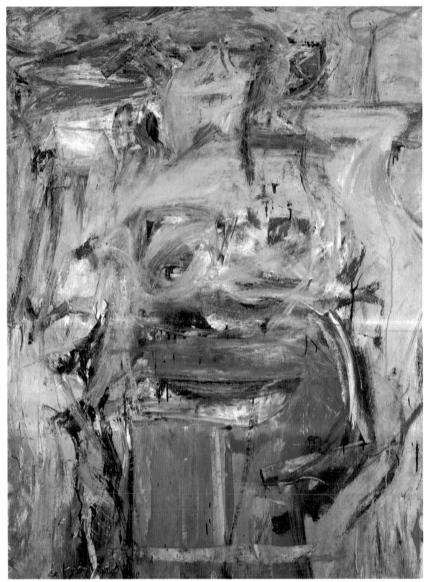

47

47.
Woman as a Landscape,
1954-55.
Oil on canvas,
65 x 47 in.
(165.4 x 119.4 cm).

48.
Composition, 1955.
Oil on canvas,
79 ⅛ x 69 ⅛ in.
(201 x 175.5 cm).

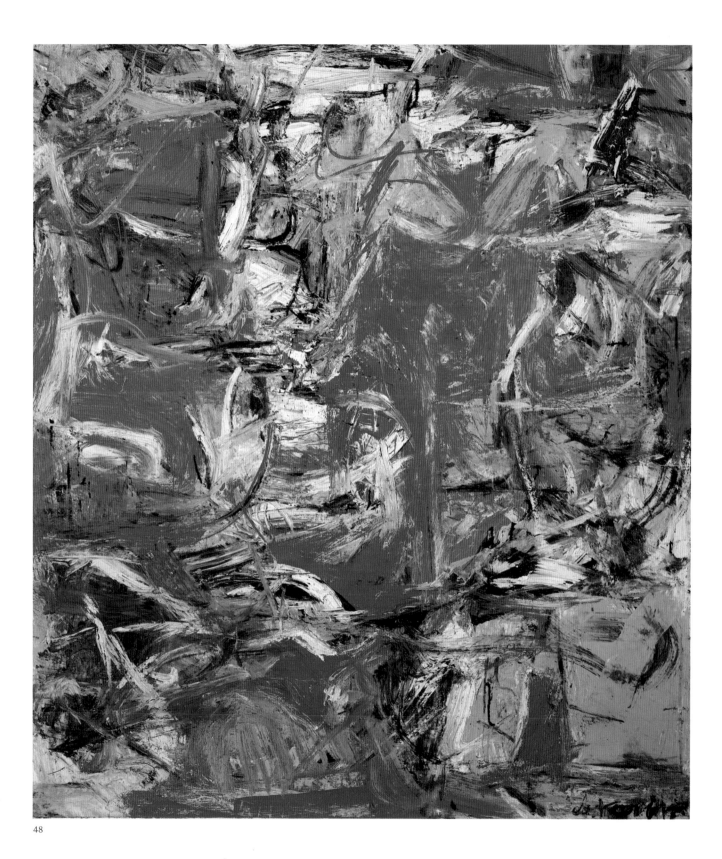

48

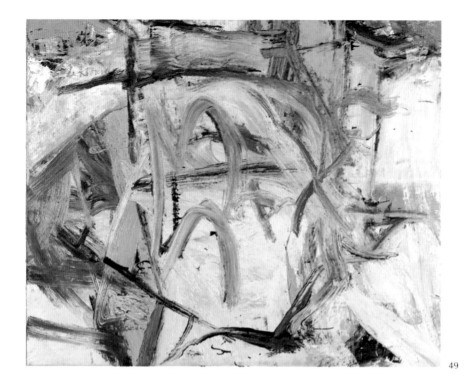

49

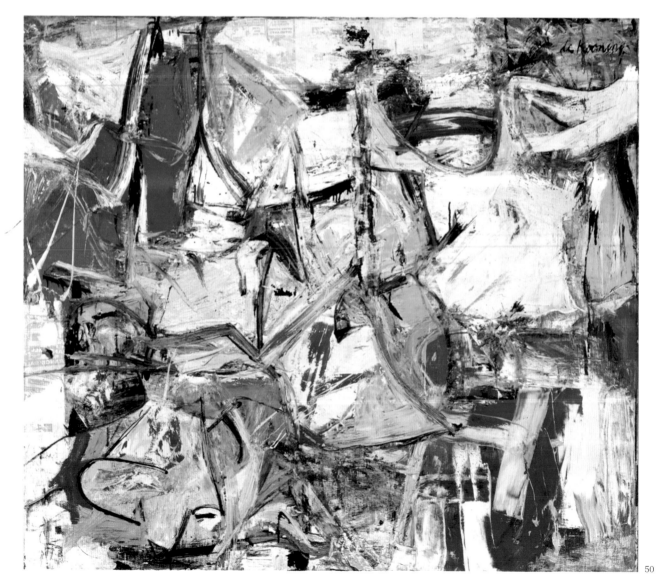

50

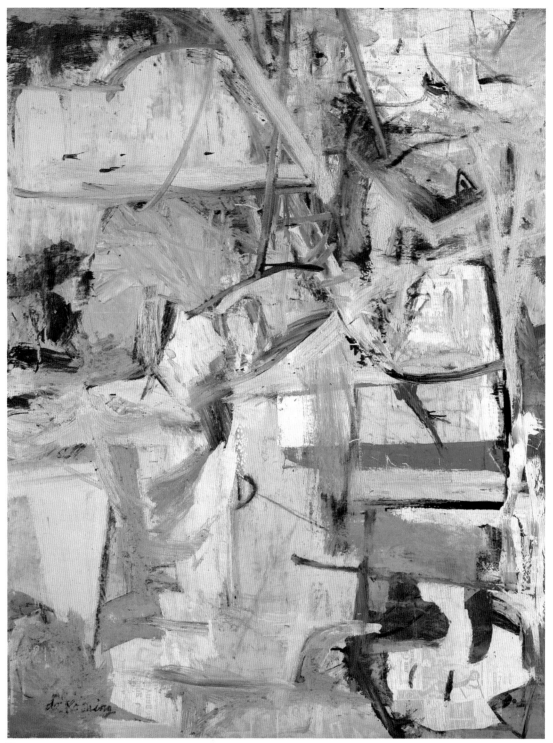

51

49.
Backyard on 10th Street,
1956.
Oil on canvas,
48 × 58 ½ in.
(122 × 148.5 cm).

50.
Gotham News, 1955.
Oil on canvas,
69 × 79 in.
(175.2 × 200.5 cm).

51.
Easter Monday,
1955–56.
Oil and newspaper
transfer on canvas,
96 × 74 in.
(244 × 188 cm).

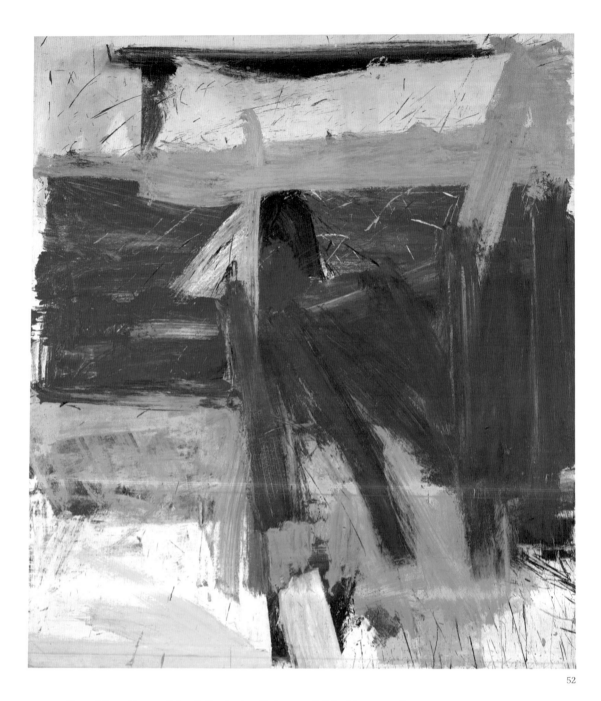

52

Invoking the void of Sartre's *Being and Nothingness* in terms that are more concrete than cosmic, de Kooning mused, "I was interested in nothingness, emptiness, empty spaces and places. All those vacant lots of buildings demolished between decaying buildings in Manhattan, the open highways and all that."[108] From *Backyard on 10th Street* (1956) to *Ruth's Zowie* (1957), the work of 1955–59 pits the vast space of the world against the arm's-length reach of the artist.[109] The paintings assume a spare eloquence by 1957, their marks fewer, more decisive and broad. Hess identified the openness and sense of speed in the works of 1957–59 with de Kooning's outings to the country.[110] De Kooning, who never learned to drive, found the long stretches and "flawless" arcs of the freeways, and the enveloping rush of landscape exhilarating. Titles confirm the effect: *Palisade* (1957), *Montauk Highway* (1958), *Merritt Parkway* (1959).

52.
Ruth's Zowie, 1957.
Oil on canvas,
80 ¹/₂ × 70 ¹/₂ in.
(204.4 × 179.6 cm).

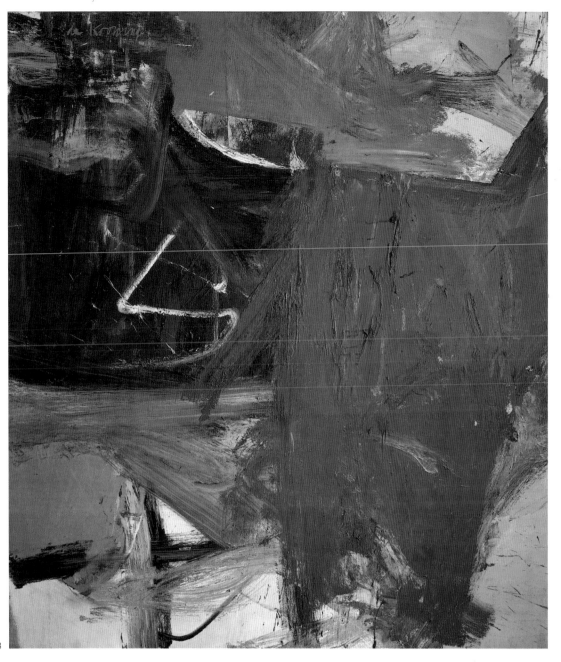

"I'm crazy about weekend drives," de Kooning confided, "even if I drive in the middle of the week. I'm just crazy about going over the roads and highways. . . . When I was working on this *Merritt Parkway* picture, this thing came to me: it's just like the Merritt Parkway. I don't think I set out to do anything, but I find because of modern painting that things which couldn't be seen in terms of painting, things you couldn't paint, for instance, are now—it's not that you paint them but it is the connection."[111] At some point in the fifties, de Kooning traveled to Cuba, his unrequited search for Hemingway's home prompting the title *Suburb in Havana* (1958).[112] Surely the resolute amplitude of the work refers as much to Hemingway's writing as to a sense of place.

By 1958 Lisabeth was a toddler and at least an occasional inter-loper in the studio, leaving handprints across *Lisbeth's Painting*. The

53.
Parc Rosenberg, 1957.
Oil on canvas,
80 x 70 in.
(203.2 x 177.8 cm).

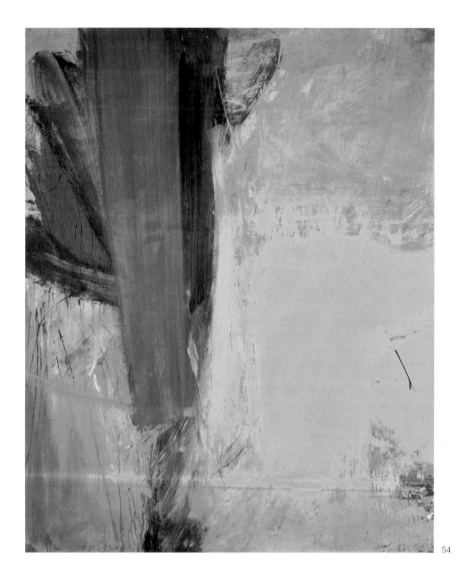

spontaneity of the child's gesture seems in keeping with the energetic execution of the painting. But a smaller work on paper made sometime earlier lays out the composition of counterbalanced strokes and colors that are played out in the large work on canvas (see plates 56 and 57). A year earlier, Rauschenberg had painted *Factum I* and *Factum II* as virtual replicas of each other. Although the paired *Factum*s, with their duplicate fragments of newspaper imagery and reiterated drips and swipes of paint, appeared a renewed attack on the alleged immediacy of action painting, in actuality they emulate as much as subvert the methods of de Kooning.

"For the first time," Dore Ashton concluded of the thirteen large abstractions exhibited in May 1959 at Sidney Janis Gallery, "de Kooning depends almost entirely on color. There was little to remind us of his past penchant for linear form determination. As always there was a good deal of scraping and underpainting. But the final picture relied on the cross passages of full brush strokes—strokes so broad that they ceased to have a linear character."[113] *Time* magazine noted the enthusiastic reception of the exhibition: the public lining up by 8:15 A.M. on opening day, nineteen of twenty-two paintings sold by noon. "Since the

54.
Montauk Highway,
1958.
Oil and combined
media on heavy-
weight paper
mounted on canvas,
59 x 48 in.
(150 x 122 cm).

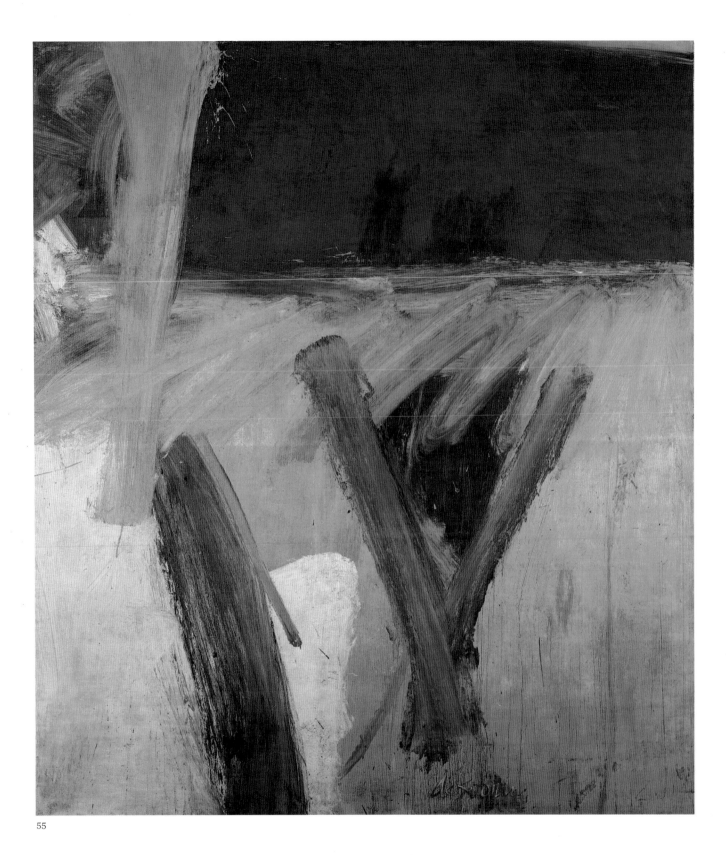

55

55.
Suburb in Havana,
1958.
Oil on canvas,
80 × 70 in.
(203.2 × 177.8 cm).

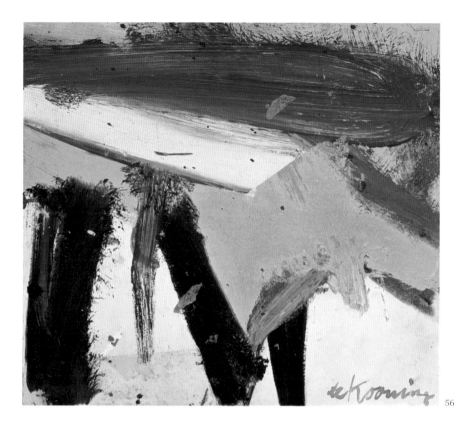

56

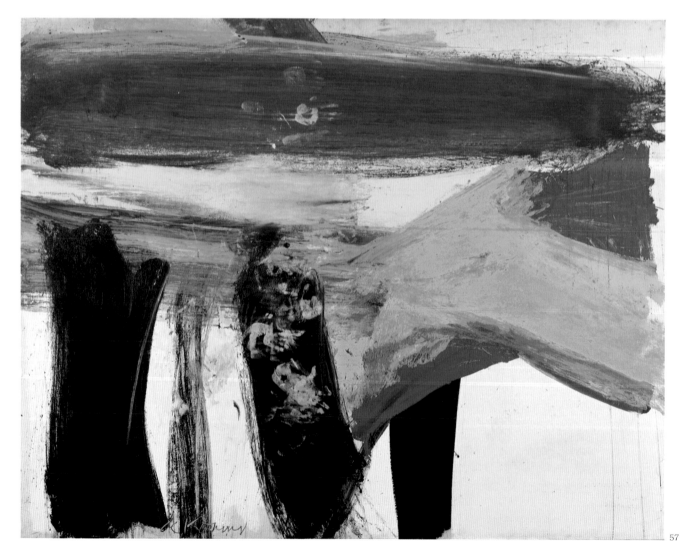

57

death three years ago of Jackson Pollock, young abstractionists in search of a style have acclaimed as their leader New York City's Dutch-born Willem de Kooning, 55."[114]

Yet efforts to recast de Kooning's turbulent style tended to be mired in exuberance or angst. The gestural abstraction of Robert Irwin's 1959 exhibition at Ferus Gallery in Los Angeles vouched for de Kooning's influence on a West Coast group of artists that also included Richard Diebenkorn, John Altoon, Craig Kauffman, and Billy Al Bengston. In New York, de Kooning's impact was substantial, nourishing the work of such varied artists as Joan Mitchell, Grace Hartigan, Philip Pearlstein, Larry Rivers, Al Leslie, and Jasper Johns. "One night I asked Bill how he felt about most of the New York painters painting like him," Rauschenberg recounted. "In his beautiful lingo, he said he didn't worry because they couldn't do the ones that *don't* work."[115] Although the humor of de Kooning's formidable sirens of the early fifties escaped some, it seems to have come across clearly to those who would in the sixties create the media-mimicking imagery of pop art. "De Kooning gave me content and motivation. My work evolves from that," painter Tom Wesselmann has divulged.[116]

It soon became evident to would-be successors that de Kooning's paintings were hardly the outpourings of some revelatory unconscious. Awed by works that were intricately constructed according to a perceptual logic with a rigor akin to Ludwig Wittgenstein's *Tractatus Logico-Philosophicus*, artists were unconvinced by the lingering assertions of unmitigated spontaneity. From the badgering doublings of Rauschenberg's *Factum I* and *II* to the mechanically made, silkscreened repetitions—albeit it scrupulously inexact—of Warhol's movie stars, it was above all the claims of expressionist gravity and unhesitating resolve put forth by critic-advocates of action painting that were under attack. Doubts seem to have persisted also for de Kooning. In July 1959, Robert Snyder filmed a group of veterans of the Club in the spacious studio at 831 Broadway to which de Kooning had moved in 1958. The discussion lingered over the old boondoggle of naming artistic movements, abstract expressionism in particular. De Kooning deflected a question, turning pointedly to Rosenberg to inquire, "Am I an action painter?" In the course of his answer, Rosenberg recounted the query of a British artist: Is it possible to paint a slow action painting? Intently, de Kooning interjected, "yes."[117]

In Rome from December 1959 to January 1960, de Kooning worked in the studio of the painter Afro. If expediency was no explanation for de Kooning's use of black and white in the late forties, then it may nonetheless account for the strategies of this brief stay on the Via Margutta. He set to work swiftly, purchasing paper, ink, and black paint. Probing at smaller scale the expansive gestures of the work made during the past few years, sheets of sweeping calligraphic marks and of acute, angular ones painted on both front and back were torn and reassembled.[118] The spattered drips of *Ruth's Zowie, Lily Pond*

56.
*Untitled
(Study for Lisbeth's Painting)*, c. 1957.
Oil on paper,
12 1/2 x 14 in.
(31.7 x 35.5 cm).

57.
Lisbeth's Painting,
1958.
Oil on canvas,
49 3/4 x 63 3/4 in.
(126.5 x 162 cm).

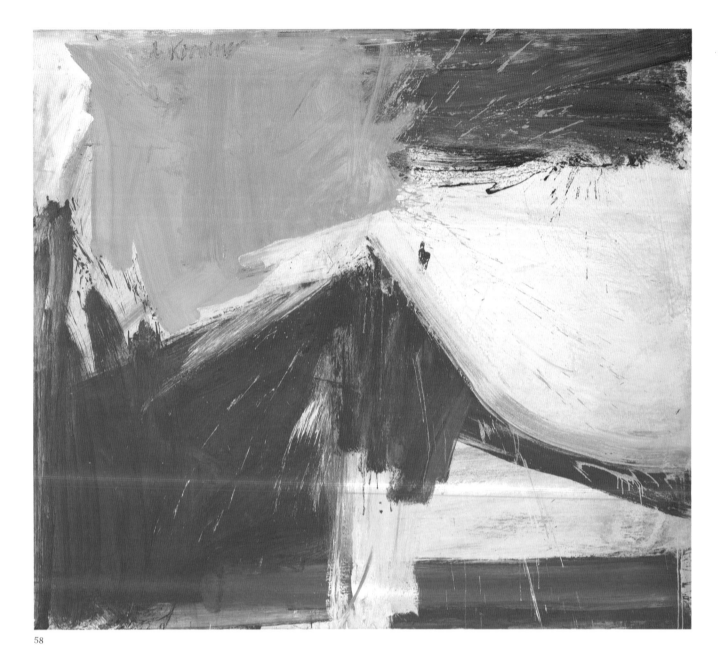

58

58.
Lily Pond, 1959.
Oil on canvas,
70 $^5/_{16}$ × 80 $^1/_8$ in.
(178.5 × 203.5 cm).

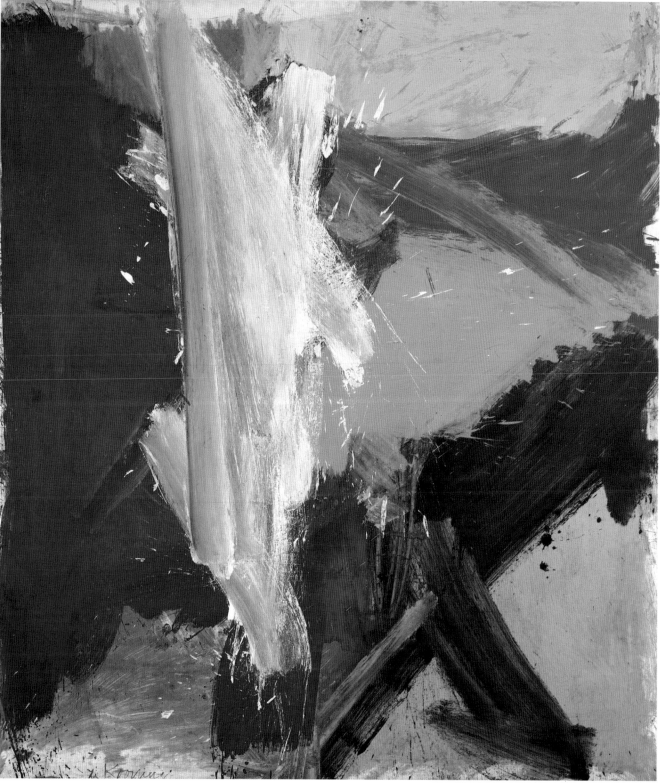

59

59.
Merritt Parkway, 1959.
Oil on canvas,
80 x 70 ½ in.
(203.2 x 179 cm).

60.
*Black and White
Rome*, 1959.
Oil on paper
on canvas,
55 ¾ × 40 in.
(141.5 × 101.5 cm).

61.
*Black and White Rome
(Two-Sided Single L)*,
1959.
Enamel on paper,
27 ¼ × 39 in.
(69.2 × 99.1 cm).

(1959), and *Merritt Parkway* are remade in more liquid splashes of enamel and ink.

Back in New York, de Kooning began to arrange his departure from the city. He had rented a house in Springs for several months in 1958, returning to Long Island the following summer. "Lee Eastman found a large house for me on Lily Pond Lane [in East Hampton], but I know it wasn't for me. There was no underbrush— it had been taken away generations ago . . . the trees have already grown up there and it looks like a park—it makes me think of people in costume and Watteau."[119] Instead, he bought less manicured land in Springs from sculptor Wilfrid Zogbaum. De Kooning's prominence extended well beyond the downtown art world now; in 1960 he was elected to the National Institute of Arts and Letters and four years later received a Presidential Medal of Freedom. All of this proved distracting. "The noisy turbulence of New York had become impossible for Bill as his reputation grew: temptations and demands on him as a public figure were crowding his painting space," painter Herman Cherry observed.[120] *A Tree in Naples* (1960), with its terra-cottas, orchid pinks, and azure blues, seems a coda to the urban decades of de Kooning's career. The goldenrod and rose palette of *Door to the River* of the same year opens onto the georgic expansiveness and ocher light of such works as *Rosy-Fingered Dawn at Louse Point* and *Pastorale* of 1963.

Taking up occasional residence in a cottage in Springs purchased in 1961 from Elaine's brother Peter, de Kooning could follow the progress of the house and studio under way according to his designs. "The plan," as Cherry understood it, "was to incorporate images relating to certain phases of his life that had persisted in his memory. The first was the captain's bridge, which reminded him of the ship that took him from Rotterdam to America as a stowaway. It jutted out from the second floor bedroom into his studio, from where you could survey the vast room. The second was to make it look like a loft—especially a factory loft of the kind in which most artists lived illegally then. . . . The third was an idea he had gotten from my studio on Cooper Square, where no room was at right angles, owing to Fourth and Third Avenues' intersecting at that point."[121] Halfway through construction and thirty-six years after the Barclay Street ferry had landed him in Hoboken,[122] de Kooning became a U.S. citizen in 1962. The next year, he gave up the loft on Broadway where he had continued to paint, renting a work space in Springs until the new studio was usable in 1964. Within the year, the house was complete. With the primal twinings of wild shrubs and woods at the edge of the yard, the Atlantic Ocean not far beyond, and dozens of bowls of paint whipped with safflower oil in the studio, de Kooning was at home. As he settled in, a pair of rush-bottomed rocking chairs were bought for the studio at a rummage sale, and pink curtains that reminded him of

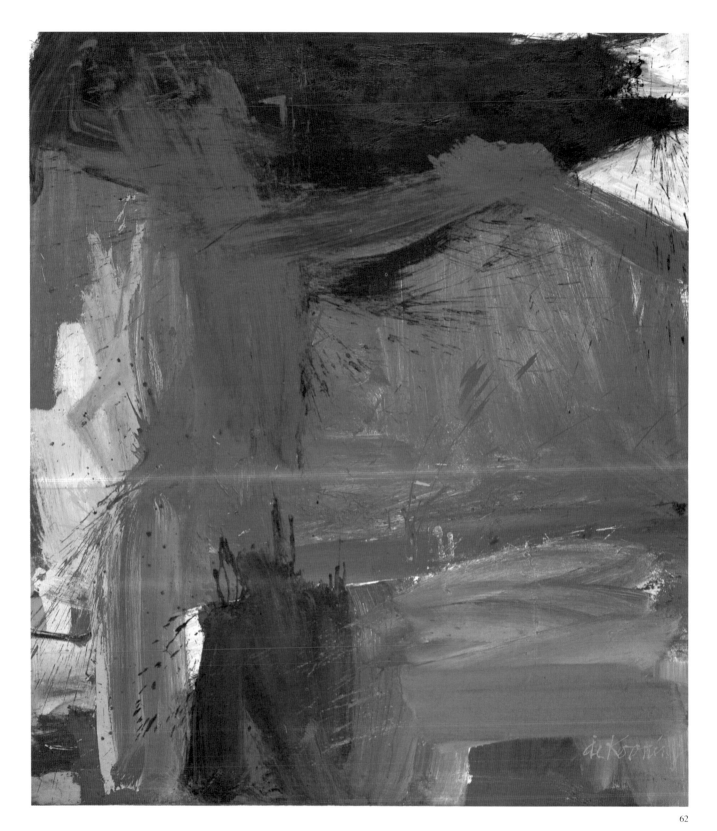

62.
A Tree in Naples,
1960.
Oil on canvas,
80 $\frac{1}{4}$ × 70 $\frac{1}{8}$ in.
(203.7 × 178.1 cm).

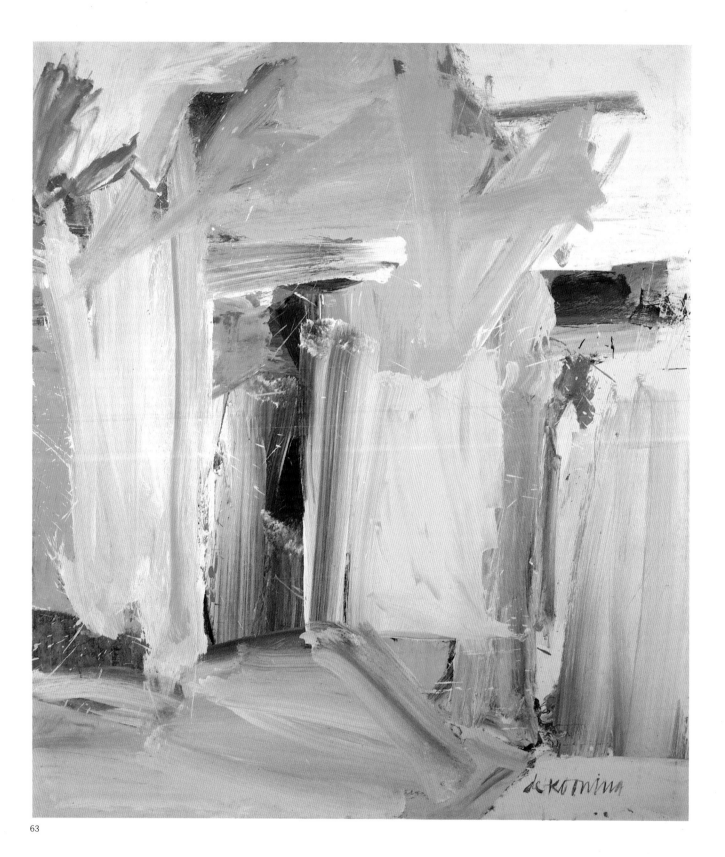

63

63.
Door to the River,
1960.
Oil on canvas,
80 x 70 in.
(203.2 x 177.8 cm).

79

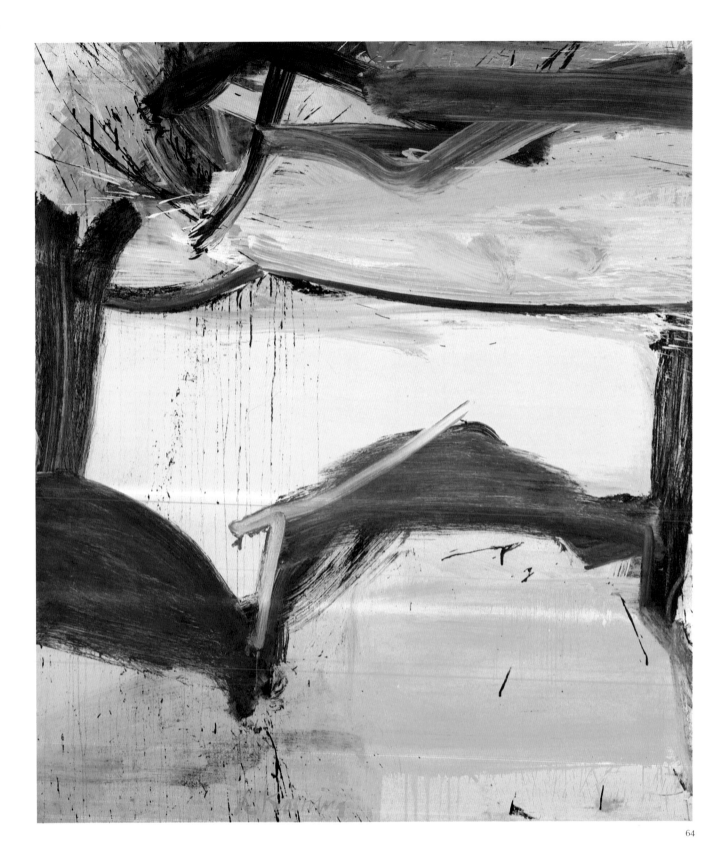

64.
Untitled, 1962.
Oil on canvas,
80 × 70 in.
(203.2 × 177.8 cm).

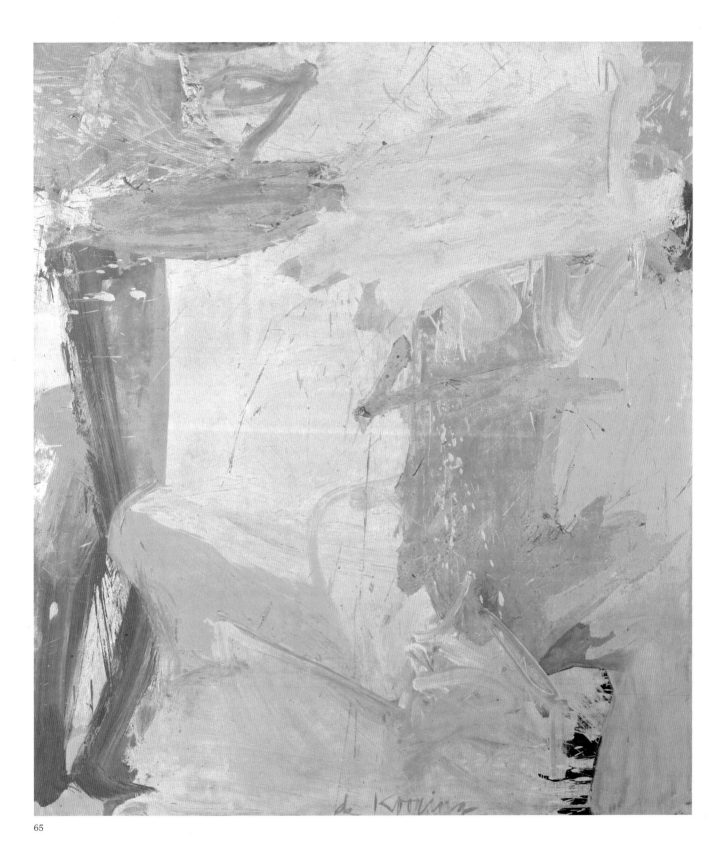

65

65.
*Rosy-Fingered Dawn
at Louse Point,* 1963.
Oil on canvas,
80 x 70 in.
(203.2 x 177.8 cm).

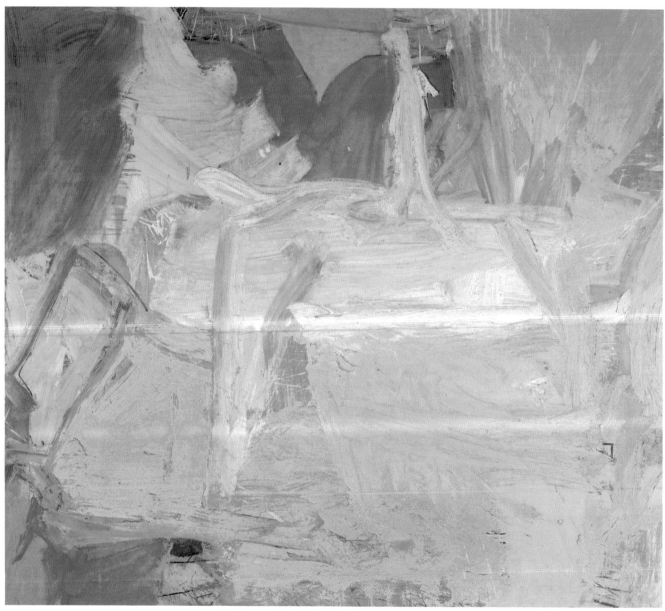

66

66.
Pastorale, 1963.
Oil on canvas,
70 × 80 in.
(177.8 × 203.2 cm).

Seventh Avenue rooming houses were installed at one end of the huge living space.[123] Perhaps to populate the new setting, de Kooning focused his large paintings over the next few years on the female figure.

• • •

As if to begin again where he had begun a decade earlier, de Kooning revisited the winning collaged T-zone smile at the center of *Woman* of 1950 in the 1961 *Woman I*. This time, a face cut from a magazine is thrown back invitingly, nearly recliningly, atop an opulent anatomy redolent of the sun-drenched palette and muscular handling of *Suburb in Havana*. De Kooning had evidently been mulling over an image encountered during the winter of 1959–60 in Rome, for the face of *Woman I* (1961) appears a commercialized recap of the countenance of Bernini's *Saint Teresa* at Santa Maria della Vittoria. That the mystical ecstasy of the saint was cast by the seventeenth-century artist in the terms of earthly love had not escaped de Kooning: "You see that face! Fantastic, hmm? and corny. Any part of that statue could be something else. The clothes could be leaves,... but then he puts that face on top and that's 'it', as if she's coming. And that foot at the bottom—fantastic."[124] The borrowed visage of de Kooning's figure, coolly in control, does more than call up the billboard confederates that had by now propelled de Kooning's T-zone toward its pop apotheoses. From the 1961 *Woman I*—hurtled backward by her photographic features—through a succession of studies made over the next few years of a reclining woman in a rowboat, there is an insistent horizontality of pose. During the sixties, the contours of the women dissipate, the last recalcitrant volumes smoothed out, as breasts flatten sideways—from *Woman I* (1961) to *Woman Accabonac* (1966).

In 1964 the Bernini image surfaced again, in a pair of drawings—one traced after the other (see plate 73)—linked with the paintings on doors, which they match in dimensions, undertaken that year.[125] De Kooning had been intrigued by the size and proportions of doors left unused during construction, dragooning these for a group of paintings and following their dimensions in related images of 1964–66. In both 1964 drawings, the oddly banal descriptiveness with which the face is rendered lacks the sexual overtones of the 1961 painting with collaged face. But the disconti-

67.
Gianlorenzo Bernini.
Ecstasy of Saint Teresa,
1647–52.
Marble,
11 feet 6 in. (3.5 m)
high.

67

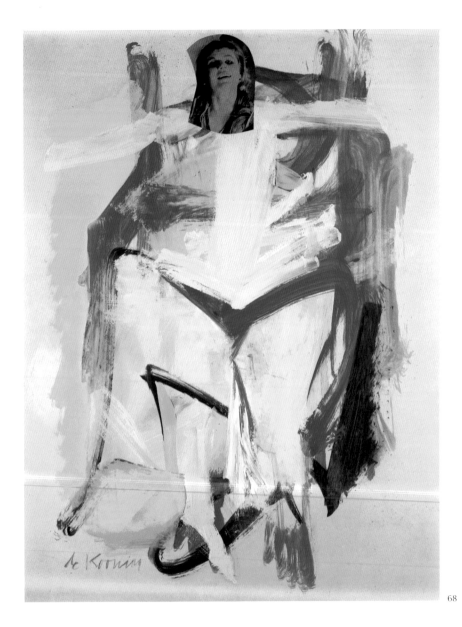

68.
Woman I, 1961.
Oil on paper
with collage,
29 x 22 ³⁄₈ in.
(73.5 x 56.8 cm).

nuities of handling remain, the face jarringly dissociated from the amorphously described body that is anchored just above the shoulders by a horizontal bar. Elaborate waverings of charcoal absorb the anatomy, in emulation of the opulent folds that "could be leaves" that overtake the body of Bernini's saint.

Graceful and rather conventionally pretty, *Woman* (1965) is vivacious, as if she has paused to greet us from a twirl. *Woman Accabonac* is born a twin to the 1965 *Woman*, both works painted on paper the size of a door. Whatever the techniques of copying and tracing, the doubling was registered in a photograph of the studio taken in 1965 or 1966. Recorded by an assistant, the emergence of *Woman Accabonac* followed a process at once of denuding and de-idealizing—as coy enchantress turns into a fortyish woman who maybe "makes hats."[126] In the course of the dozen or so documented phases, the costume swirls across the figure to become at last only so much paint. The final pose of *Woman Accabonac* is the result of sufficient scraping and reworking that the paper was torn and repaired with masking tape cut into the shapes of

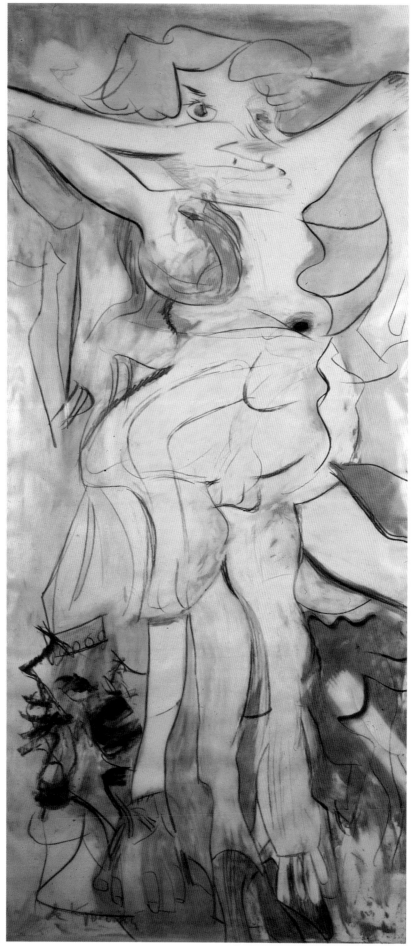

69

69.
Woman, 1965.
Oil, pencil, and
charcoal on paper,
79 ¹/₂ × 35 ¹/₂ in.
(202 × 90.2 cm).

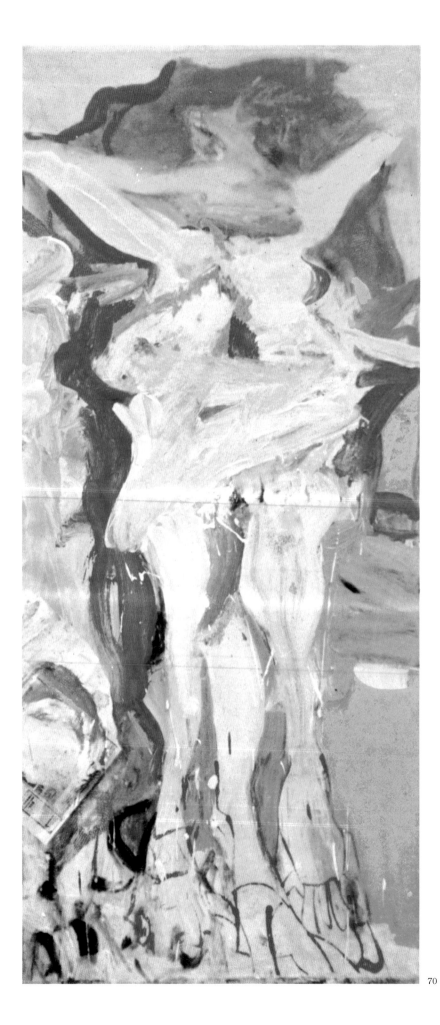

70.
Early stage of
Woman Accabonac.

70

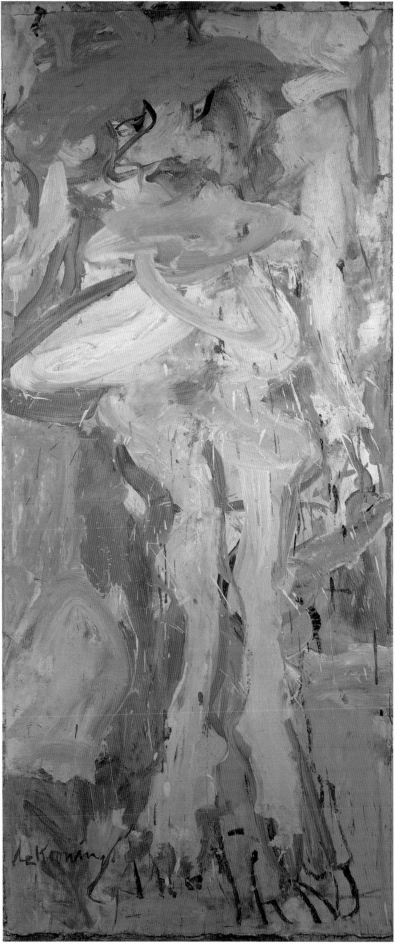

71

71.
Woman Accabonac,
1966.
Oil on paper
mounted on canvas,
79 × 35 in.
(200.5 × 88.8 cm).

bandaids and duly painted over. Tape, too, originally affixed the paper on all four sides to a more sturdy support in the studio. Clotted with pigment and pointedly revealed in the framing, this tape surround follows the strip frame of *Black Friday* in exposing process and subverting boundaries. Swipes of impasto abutting smooth stretches and wrinkled skins of pigment do the work initiated by pentimental and newspaper-transfer passages of earlier decades: they haul the viewer up close into a sort of empathy with the work of the artist.

In *Woman Accabonac* de Kooning had painted the kind of figure he would describe as "light, soaring upward, instead of heavily attached to the ground. I pose a nude in the highest heels made so she has an upward movement—then when I paint her, I leave out the shoes."[127] And so would seem to be the progress of *Woman Accabonac*, except that de Kooning did not leave out the shoes. More constant than any other detail throughout the unfolding of the painting is the persistence of a high-heeled shoe at lower center, directly transcribed from *Woman* (1965). It steps unmistakably from our direction: an unnoticed presence facing the figure, insinuating an embrace, or at least the intertwined legs of a slow dance. De Kooning contemplated for a time installing the women on doors side by side like Byzantine saints. Maybe he hoped by this tactic to envelop the viewer—to achieve what Georges Duthuit had in 1949 described in the essay "Matisse and Byzantine Space": "the space of a picture is the one we actually breathe in."[128]

De Kooning wanted the charcoal *Woman* (1964) to recline, reporting to a friend that this was a figure lolling in a rowboat.[129] But the woman stiffens, blocked in verticality like Rauschenberg's *Bed* (1955). The effect of idyllic outing was more legible in the series of charcoal and pencil women in realistically drawn rowboats begun the same year. At the outset, the woman in a rowboat is gay, prosaic, though she becomes progressively less distinct. The unexpectedly quotidian look of the initial boats suited the purpose of forcing the figures' horizontality. But behind the Proustian charm of the idea there is, perhaps, a more drastic model, as the splayed legs of reclining women encased by the ribs of rowboats echo Giacometti's *Woman with Her Throat Cut* of 1932.[130]

As though following the rocking rhythm of a rowboat moored in placid waters, the pose of *Woman in a Rowboat* (1964) fluctuates. In one reading, the figure's legs are slung over left and right sides of the vessel; in the other, her left leg is extended more casually in the

72.
Alberto Giacometti.
*Woman with
Her Throat Cut*, 1932.
Bronze,
8 x 34 1/2 x 25 in.
(20.3 x 87.5 x 63.5 cm).

72

center of the boat. The drawing points in two directions: toward *Woman, Sag Harbor* (1964), and to *The Visit* (1966–67). The boat is long gone in the paintings—too literal, anecdotal. Cut loose from the rowboat, *Woman, Sag Harbor* has lost all sense of repose. Ambiguous in position, vacillating between upright and supine postures, she is elusive in mood: is this rage or passion, abjection or frolicsomeness? Early in 1965 *Time* magazine ran a prescient account of the "new women": "As 'action' paintings, they are products of De Kooning's encounter with the sensuous nature of oils. As forms caressed within the bear-hug space of the painter, they seem to be violent Valentines, icons to love's agony."[131] In an onslaught of shuddering images of women in the water, on a sign, on a dune, in the landscape, that reach in time from *The Visit* to *Easthampton VI* (1977), what looks like some elemental scene is replayed. Spattered with paint, the figure at the center of *The Visit*, reputed to be sitting on a rock by one account,[132] sprawls as if in a posture of birthing or of sex, a primordial chthonic force, aqueous, earthen, embracing, consuming. In *The Visit* the strain between abstraction and figuration is so taut as to alarm.

Or perhaps it is summer and these are swimmers: frog kick of *The Visit*, backstroke glide of *Woman Accabonac*, sidestroke of *Woman, Sag Harbor*. In 1964 de Kooning had claimed, "I'm working on a water series. The figures are floating, like reflections in the water."[133] Maybe the busty silhouette of *Woman Accabonac* and the inchoate face of *The Visit* are really just the magnified waverings of images adrift at sea—a sort of figurative extension of Monet's *Waterlilies*. Or de Kooning might have had in mind a moment in *Two Serious Ladies* when the nude Pacifica "during the course of her swimming . . . rested on a large flat rock which the outgoing tide had uncovered. She was directly in the line of the hazy sun's pale rays. Mrs. Copperfield had a difficult time being able to see her at all and soon she fell asleep."[134] But if the figures look liquid, the paint is viscous as the meditation on physicality brings us back once more to the material substance of the painting itself.

In their ambivalent postures, those sensualists and would-be saints painted by de Kooning in the sixties fluctuate between abandon and restraint, as if embodiments of the dualities that de Kooning found compelling in Faulkner's *Requiem for a Nun*: "The faces omnivorous and insatiable and forever incontent: demon-nun and angel-witch; empress, siren, Erinys: Mistinguett, too."[135] In *Requiem for a Nun*, as in *Light in August*, a death and a death sentence follow with Oresteian inevitability from some scenario of illicit sex, grim evidence in support of Kierkegaard's reading of the Christian imagery of Original Sin: "After the word of prohibition follows the word of judgment: 'You shall certainly die.'"[136] Sometime in the late sixties de Kooning sketched, in passing, an uncanny crucifixion. The crucified man, feet apparently nailed together as in virtually every other

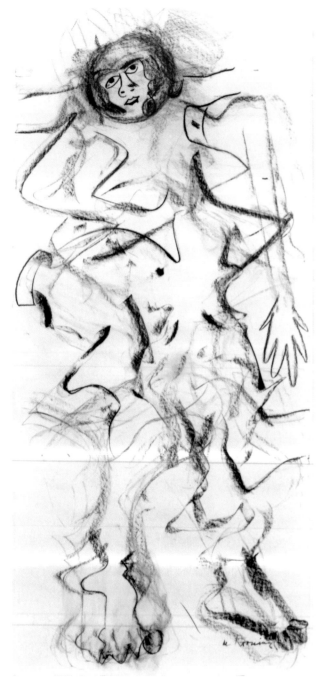

73

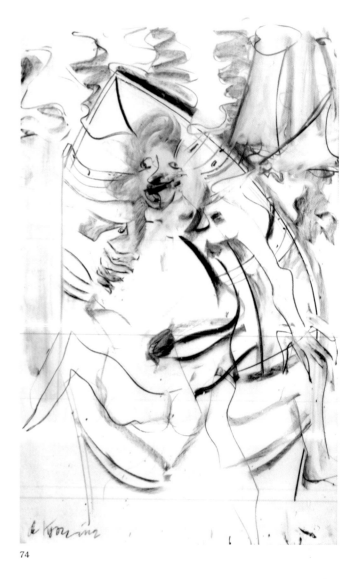

74

73.
Woman, 1964.
Charcoal on paper,
79 x 37 in.
(200.5 x 94 cm).

74.
Woman in a Rowboat,
1964.
Charcoal on paper,
58 x 35 ½ in.
(147.3 x 90.2 cm).

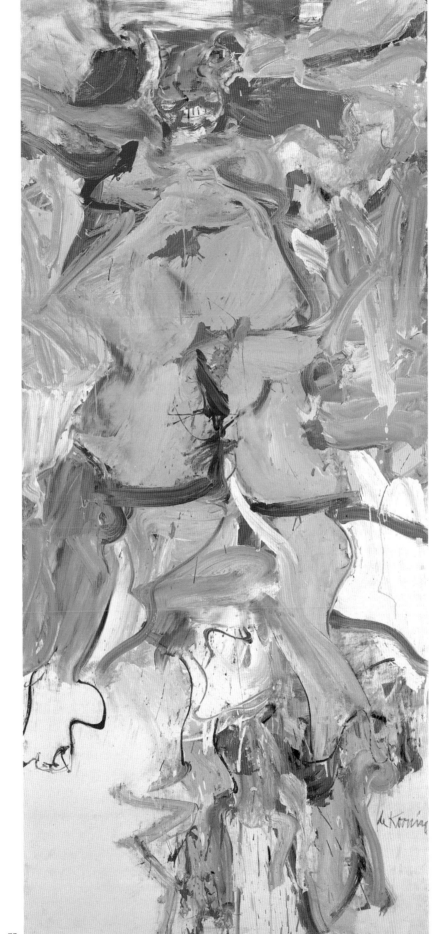

75

75.
Woman, Sag Harbor,
1964.
Oil and charcoal
on wood,
80 x 36 in.
(203.2 x 91.4 cm).

crucifixion de Kooning drew in 1966 and 1967, is suspended from a cross that Jung had envisioned: it is a woman. "Perhaps the historical example of the dual nature of the mother most familiar to us is the Virgin Mary, who is not only the Lord's mother, but also, according to medieval allegories, his cross."[137]

"One can hardly imagine," Jung reasoned of the Christian imagery of crucifixion, "a symbol which expresses more drastically the subjugation of instinct. Even the manner of death reveals the symbolic content of this act: the hero suspends himself in the branches of the maternal tree by allowing his arms to be nailed to the cross. . . . This act . . . is a crushing defeat for man's animal nature, and it is also an earnest of supreme salvation, because such a deed alone seems adequate to expiate Adam's sin of unbridled instinctuality."[138] If arms and hands of the figures in de Kooning's archetype-laden crucifixion of the sixties are melded, then too there is some problem in knowing whose legs are whose. If the pose of crucifixion locks together two feet, a third appears. A better match for the rough rendering of toes at right, it confoundingly displaces the central leg. Wavering in direction, the foot in the middle points toward the third foot of *Woman* (1965), her diaphanous golden mantle a match for the Guinevere tresses of the cruciform woman in the drawing.

"Bill always had the crucifix in the back of his mind. He always wanted to do a crucifixion," Elaine de Kooning remembered, "but how would you deal with the body?"[139] Despite the dozens of crucifixion drawings made over the years, de Kooning would no more have painted a cross than he would have a rowboat—too narrative and dependent on

76.
Untitled, late 1960s.
Charcoal and pencil on tracing paper,
18 ³/₄ x 21 ¹/₄ in.
(47.5 x 54 cm).

77.
The Visit, 1966–67.
Oil on canvas,
60 x 48 in.
(152.5 x 122 cm).

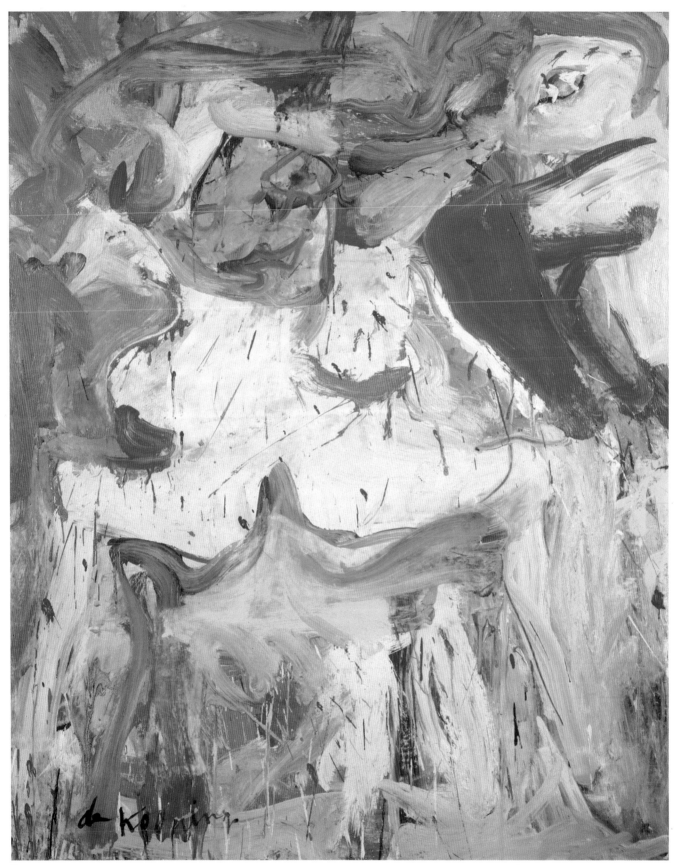

77

78 79

depiction, intractably secondhand. Perhaps the crucifixion lingered "in the back of his mind" as a mythic construct, like the labyrinth, devised to quell "unbridled instinctuality." Not because de Kooning believed the metaphysics of Christianity, but because he recognized in its metaphors the abiding struggles of humanity.

It must have troubled de Kooning that Rosenberg's position piece "The American Action Painters" had masked the deliberation at the core of abstract expressionism. Pronouncing that "what matters always is the revelation contained in the act,"[140] the essay had skirted any explicit discussion of the dialectic of counterforces figured in the decisive gestures and assertive reworkings of de Kooning's paintings. When de Kooning declared in 1949 that "the only certainty today is that one must be self-conscious,"[141] he meant to locate the vantage of reflection—and of responsibility—which is peculiarly human. Picasso's *End of a Monster* is marked by the literal encounter of the minotaur with his reflection in a mirror held by a sea goddess: a dawning of self-consciousness that is the death of his conscienceless animal self. Faulkner's *Requiem for a Nun* opens with "The Courthouse" and closes with "The Jail," as if in these structures of judgment and discipline civilization keeps its grip: "So, although in a sense the jail was both older and less old than the court-house, in actuality, in time, in observation and memory, it was older even than the town itself. Because there was no town until there was a courthouse. . . ."[142] Faced with the chasm of existentialism, confronted

78.
Untitled (Crucifixion),
1966.
Charcoal on paper,
17 x 14 in.
(43.1 x 35.5 cm).

79.
*Untitled (Seated
Woman on the Beach)*,
1966–67.
Charcoal on paper,
24 x 18 ¾ in.
(61 x 47.6 cm).

with the agony of World War II, the abstract expressionists had in the late forties made of painting a mode of inquiry of virtually philosophical import. Behind de Kooning's voluptuous marks and ruthless preemptings surely figures the conviction that painting is a way of working through how we are in the world.[143] In 1970 the Kierkegaardian resonance crucial to de Kooning at last came clear in Rosenberg's "The Diminished Act." What engrossed de Kooning particularly in the essay was Rosenberg's inquiry into the conjecture framed by Dostoevsky in *Crime and Punishment* that "a crime that is large enough—Napoleon's total of slain, in contrast to Raskolnikov's—overwhelms the concept of guilt by taking on the character of a natural catastrophe." "Blended into world events," Rosenberg observed of the defense contrived at Eichmann's trial in Jerusalem, "the acts of Eichmann tended to shrink into a mere nuance of personality ('If he hadn't done the job, someone else would')."[144] The act, for de Kooning as for Rosenberg, must be owned by the actor, judged without determinist apology. The alternative is a terror that is diffuse, a responsibility that cannot be called to accounts.

·　　　·　　　·

De Kooning and Sidney Janis began a legal tussle in 1965. The next year Allan Stone Gallery showed paintings of women, and Knoedler and Co. became de Kooning's dealer, presenting recent work in New York in 1967 and arranging an exhibition at Knoedler in Paris during summer 1968. Having somehow assuaged de Kooning's anxiety about retrospectives—"they tie you up like a sausage and then you're finished"[145]—Hess curated for the Museum of Modern Art in New York a major exhibition of de Kooning's work that first opened in 1968 at the Stedelijk Museum in Amsterdam, traveled to the Tate Gallery in London, and returned to the States in 1969 to an itinerary that included the Museum of Modern Art, the Art Institute of Chicago, and the Los Angeles County Museum of Art. Writing in *Newsday*, Emily Genauer was preoccupied with the women who seemed to her to be de Kooning's obsession. Struck by their link with the "gross, destructive, monstrous, consumed and consuming caricature" that she had discerned in Philip Roth's just published *Portnoy's Complaint* (1969), she herself objected: "[De Kooning] flays [the women], beats them, stretches them on racks, draws and quarters them. . . . It isn't the contempt in de Kooning's works that I mind, per se. It's the absence of wholeness and diversity in a great talent who seems to have chained himself to a leering, lynx-eyed totem pole."[146]

Spending the final summer of the decade in Rome, de Kooning met up with sculptor Herzl Emanuel, whom he had known some years earlier. Visiting Emanuel's bronze-casting foundry, de Kooning began work on a group of small sculptures. The clay forms, to be cast in bronze, were modeled often without looking—a sort of three-dimensional variant on a

80

80.
*Two Figures
in a Landscape,* 1968.
Oil on paper,
48 ¹/₂ × 60 ⁵/₈ in.
(122.5 × 154 cm).

81.
Women Singing I,
1966.
Oil on paper,
36 ¹/₈ × 24 ¹/₄ in.
(91.7 × 61.5 cm).

81

96

82

82.
Montauk I, 1969.
Oil on canvas,
88 × 77 in.
(223.5 × 195.5 cm).

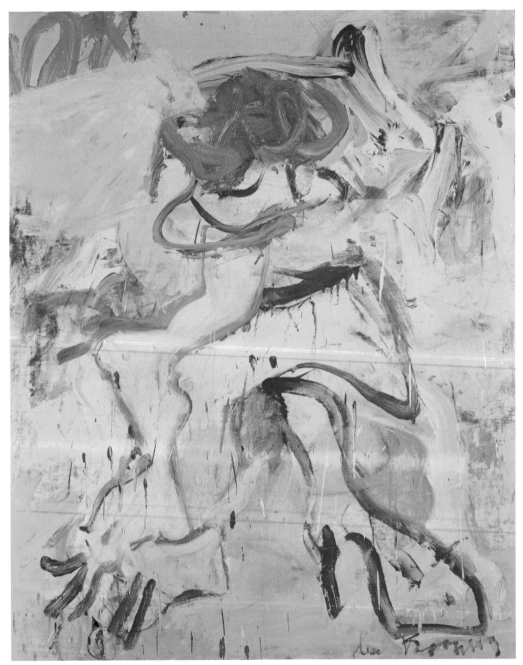

83

83.
Woman, 1970.
Oil on canvas,
60 x 48 in.
(152.5 x 122 cm).

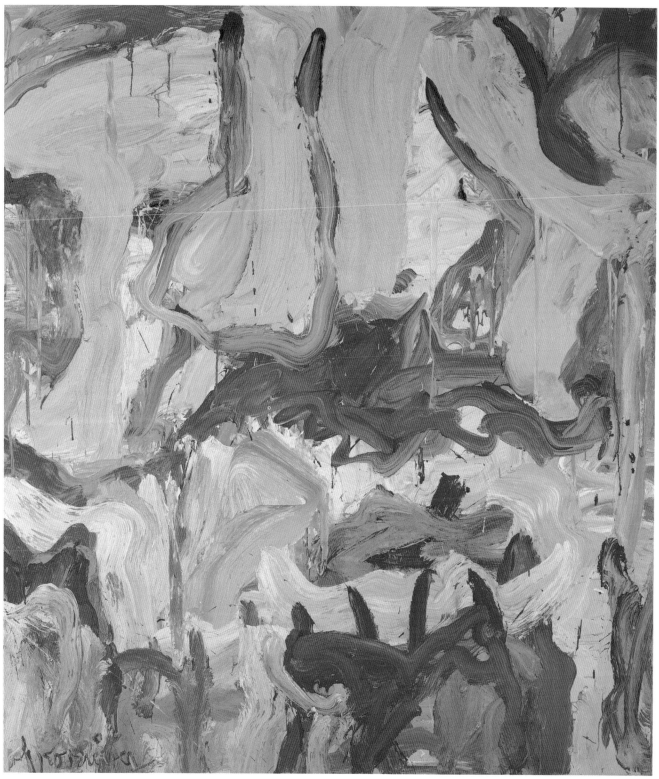

84

84.
*Landscape of an
Armchair*, 1971.
Oil on canvas,
80 x 70 in.
(203.2 x 177.8 cm).

group of drawings gathered into a book of 1967 with the explanation "I am the source of a rumor concerning these drawings, and it is true that I made them with closed eyes."[147] Back in New York, de Kooning explored sculpture at larger scale. Tactile in their fabrication, the works were at least partly optical in inspiration. The "stolid, glowering figure of Neanderthaloid maleness" that was the *Clamdigger* (1972) was prompted, de Kooning told critic Peter Schjeldahl, by the wavering contours of clamdiggers lit from behind by the sun in the shallows at Montauk.[148] All of the sculptures center on the human body, from *Untitled No. 13* (1969) to *Cross-Legged Figure* (1972). *Hostess* (1973) "started out to be a saint. But then she became a hostess, like Mrs. Luce." And once she was exhibited as a *Bar Maid*.[149] Working with clay was in some ways a respite from painting. "If you don't like it, you just smack it with a two-by-four and it's gone and you start over."[150]

The sculpture may have sapped the figure from the paintings, for in the next several years, place overtakes person in the enduring economy of de Kooning's painterly content noted by Robert Creeley.[151] The paintings of the seventies pursue the promise of color described to Rosenberg in 1972: "When I came here [to Springs] I made the color of

85.
Untitled No. 13, 1969.
Bronze,
15 ½ x 12 x 4 ½ in.
(39.5 x 30.5 x 11.5 cm).

100

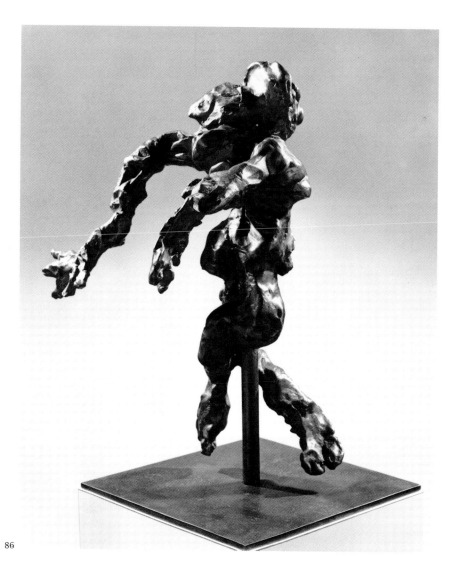

86

sand. . . . As if I picked up sand and mixed it. And the grey-green grass, the beach grass. . . . When the light hits the ocean there is kind of a grey light on the water. . . . I had three pots of different lights. . . . Indescribable tones, almost. I started working with them and insisted that they would give me the kind of light I wanted. One was lighting up the grass. That became that kind of green. One was lighting up the water. That became that grey. Then I got a few more colors, because someone might be there, or a rowboat, or something happening. I did very well with that. I got into painting in the atmosphere I wanted to be in. It was like the reflection of light. I reflected upon the reflections on the water, like the fishermen do."[152]

In their dense and tangled fabric of pigment the works invoke the land in Springs: "I was always fascinated with the underbrush . . . the entanglement of it. Kind of biblical. The clearing out . . . to make a place."[153] Like the landscape, the paintings seem images of germination and renewal. "The land around my place is covered with scrub oak, skinny trees that last only about fifty or sixty years; then they die, then grow up again. So the place looks pretty much now as it did centuries ago, in the Stone Age, when the Indians were here. So that's

86.
Cross-Legged Figure,
1972.
Bronze,
24 1/2 x 17 3/4 x 16 in.
(62.2 x 45 x 40.5 cm).

101

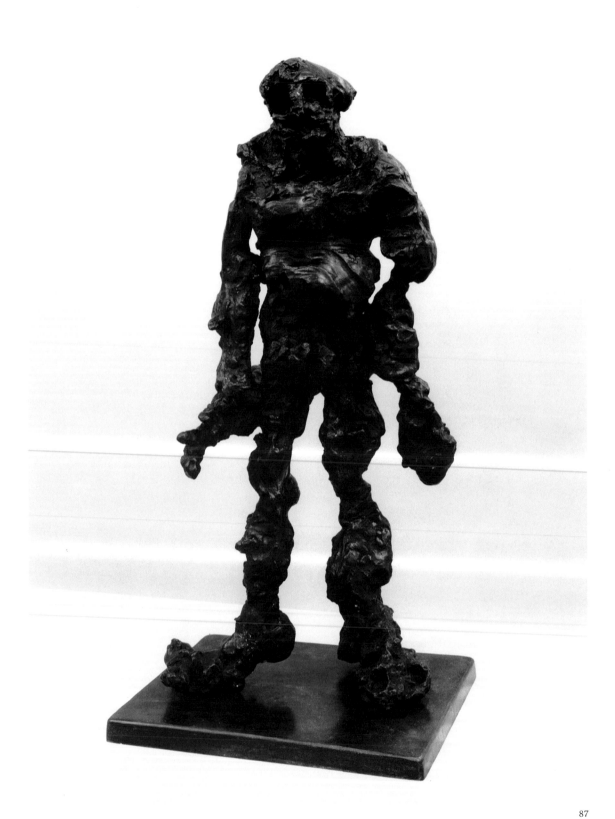

87.
Clamdigger, 1972.
Bronze,
57 ¹⁄₂ x 24 ¹⁄₂ x 21 in.
(146.1 x 62.2 x 53.3 cm)

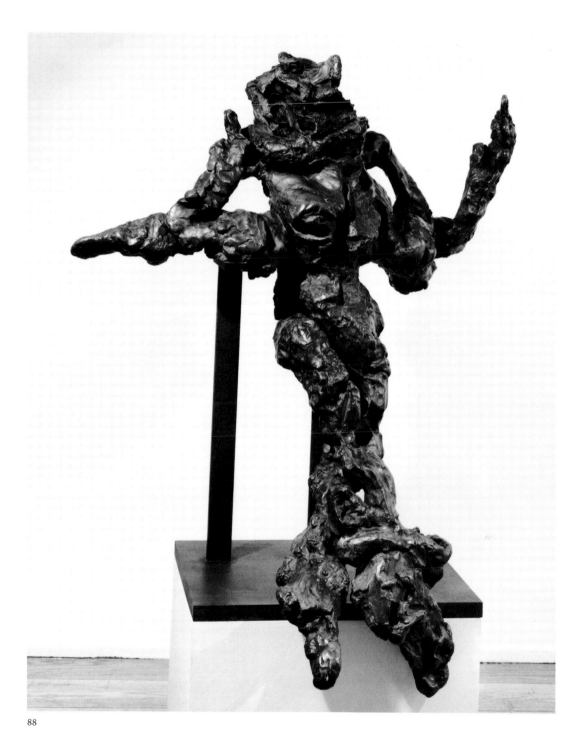

88

88.
Hostess, 1973.
Bronze,
49 x 37 x 29 in.
(124.5 x 94 x 73.5 cm).

Timelessness! Scrub oaks. Isn't it strange, with all the romantic talk about the Timeless, that it's really commonplace?"[154] Enraptured manipulations of material form, the surfaces of the seventies are a topography of roiling complexity. By 1975 de Kooning made regular use of a variation on the newspaper transfers of 1949–56. Sheets of plain paper laid across the wet paint were pressed tight and then moved slightly. Like the offset legends of an earlier era, the effect of shifting focal lengths tugs the viewer nearer.

In 1972 Xavier Fourcade left Knoedler, joining with Donald Droll to establish Fourcade, Droll, Inc., which represented de Kooning until 1976. That year Fourcade set up a gallery on his own, taking over the handling of de Kooning's work. A one-person exhibition organized by the Hirshhorn Museum and the USIA toured eastern and western Europe in 1977–78. The Guggenheim Museum arranged *Willem de Kooning in East Hampton* in 1978, and a major one-person exhibition at the Carnegie Institute was presented in 1979. After a separation of some twenty years, Elaine moved to a house in Springs, setting up a life with Willem.

The brushstrokes broadened in 1981, as if a momentary recollection of the late fifties. But the lavish color and sumptuous impasto quickly turned spare. The paintings after 1982 seem to skim the lines from the surfaces of such paintings as *"...Whose Name Was Writ in Water"*—the 1975 title excerpted from Keats's epitaph. Arcs of color across chalk-white fields rise and subside in the eighties, calling up the more craggy *Excavation* and completing a cycle started half a century earlier in paintings that defer to drawing. "Still exuberant," David Rosand wrote of paintings of 1981 and 1982 included in the retrospective that opened in December 1983 at the Whitney Museum of American Art, "their designs and energies clearly relate to all that preceded them. And yet they are different: the rhythms are much more deliberate, meditated even, and the space more open. Gestures still recall the physiognomy of their origins in the body, but within their monumental calligraphy a new order prevails, a new calm. Most revealing, perhaps, the visceral quality of paint itself has been chastened. Scraping and smoothing, de Kooning has purified his stroke, and what had been quintessentially sensuous is rendered immaterial, ethereal, a veiled tracing of its physical origins."[155] Struck by the "sheer vigor of attack" evident in the exhibition that spring at Fourcade, Vivien Raynor wrote in the *New York Times* "that de Kooning, who has never strayed far from nature for long, is closer to it now than ever. But it's the side of nature that's invisible to the naked eye. These are curves, not of human bodies and landscape, but of micro-organisms, and the space they tumble and squirm in could well be liquid, not air."[156] As if de Kooning has returned to the aqueous, generative realm of *Elegy*.

With the death in 1987 of Fourcade, de Kooning was besieged with alternatives. Following Elaine's death in 1989, his reluctance to choose a new gallery was revealed as incapacity. De Kooning's flagging memory

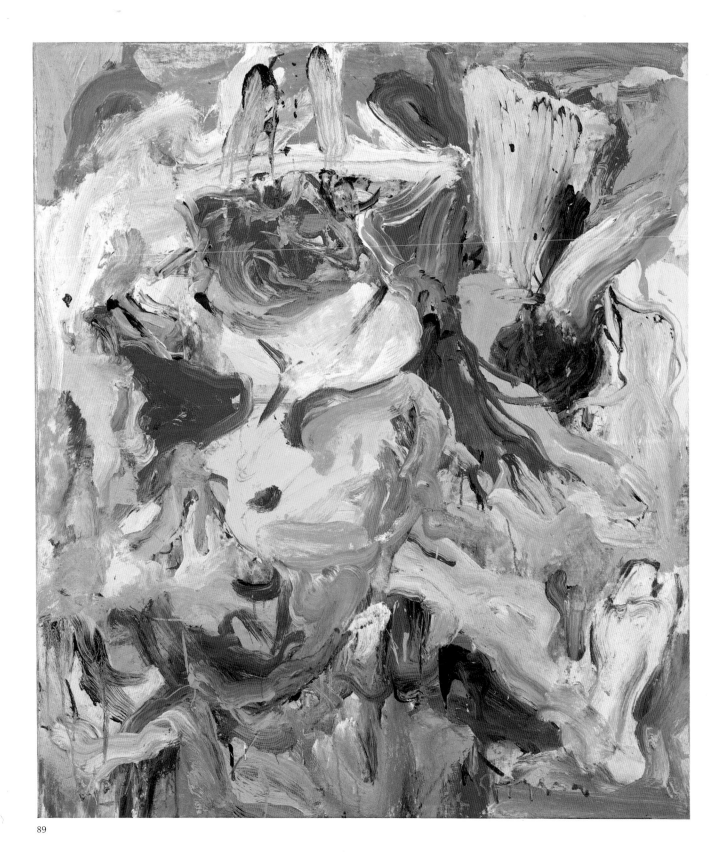

89

89.
*La Guardia in a Paper
Hat*, 1972.
Oil on canvas,
55 ³/₄ × 48 in.
(141.5 × 122 cm).

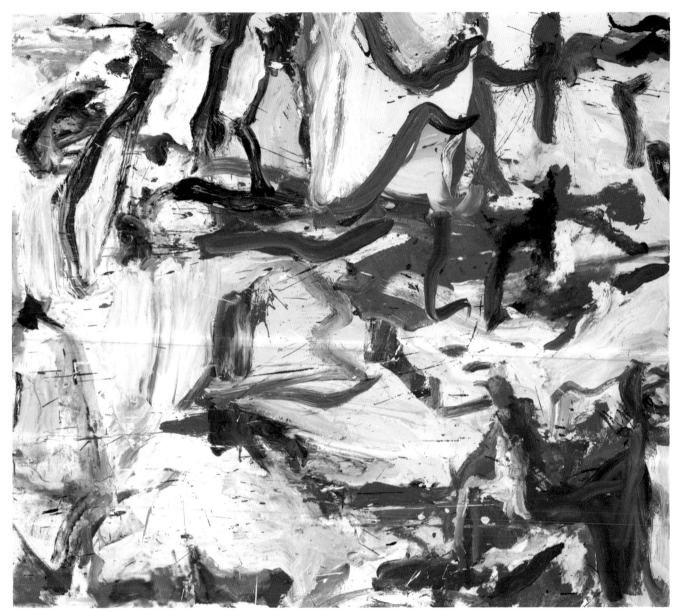

90

90.
*. . . Whose Name Was
Writ in Water,* 1975.
Oil on canvas,
77 × 88 in.
(195.5 × 223.5 cm).

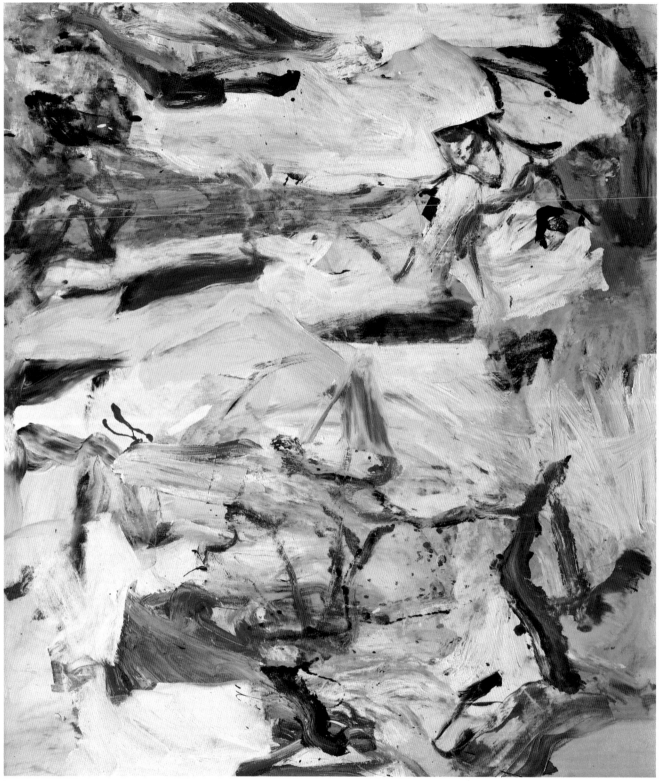

91

91.
North Atlantic Light,
1977.
Oil on canvas,
80 x 70 in.
(203.2 x 177.8 cm).

92

92.
Untitled XIV, 1977.
Oil on canvas,
55 × 59 in.
(139.7 × 150 cm).

93.
Untitled III, 1979.
Oil on canvas,
60 ¼ × 54 in.
(153 × 137 cm).

93

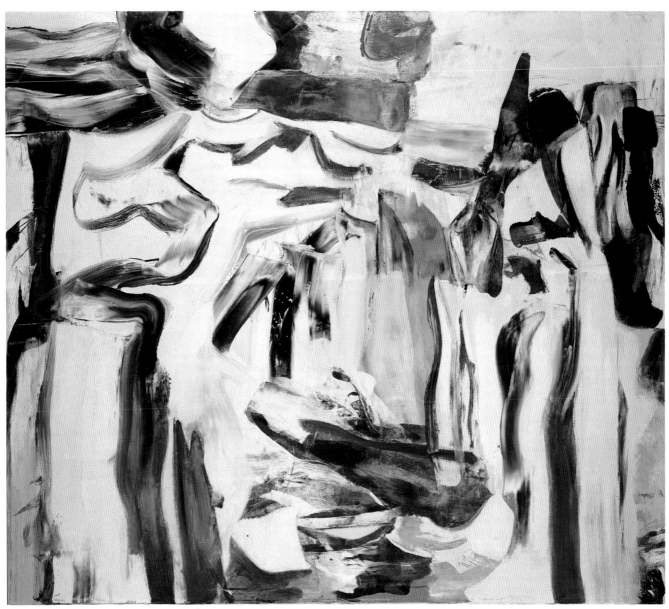

94

94.
Untitled V, 1980.
Oil on canvas,
70 × 80 in.
(177.8 × 203.2 cm).

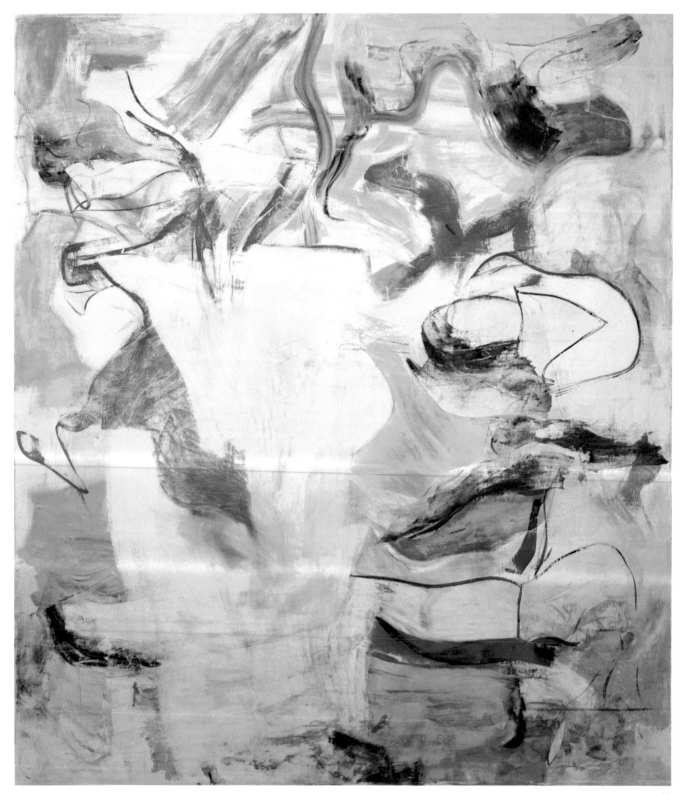

95

95.
Pirate (Untitled II),
1981.
Oil on canvas,
88 × 76 ¾ in.
(223.5 × 195 cm).

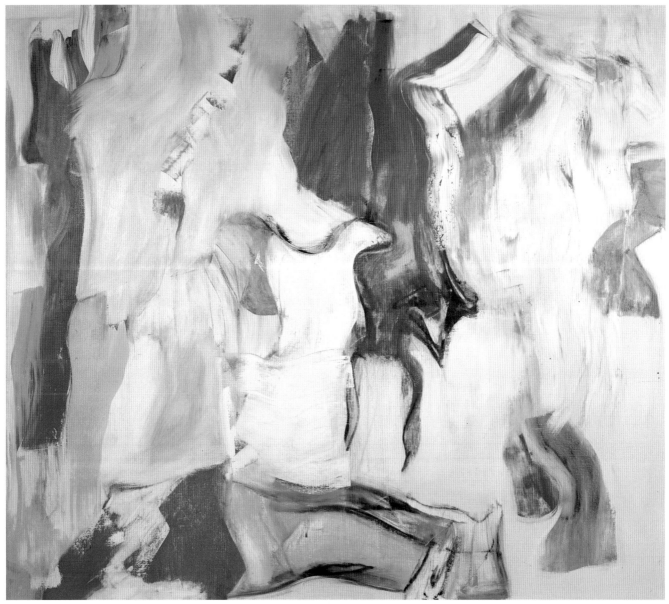

96

96.
Untitled VI, 1981.
Oil on canvas,
77 × 88 in.
(195.5 × 223.5 cm).

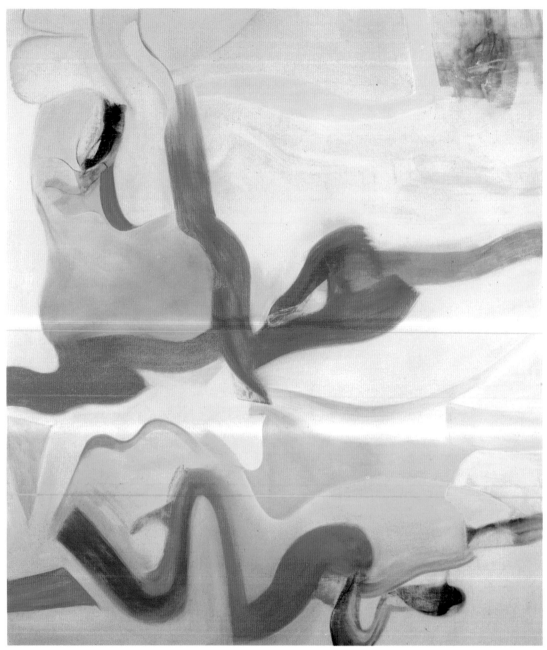

97

97.
Untitled III, 1982.
Oil on canvas,
80 × 70 in.
(203.2 × 177.8 cm).

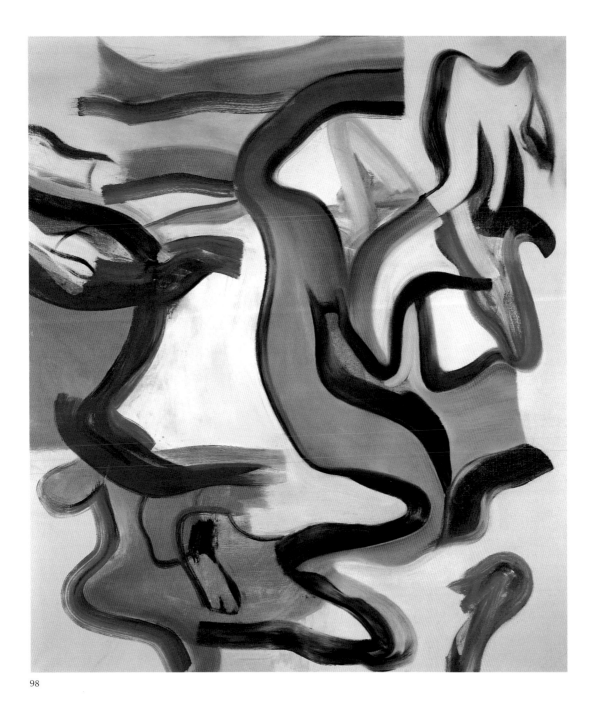

98

98.
Untitled VI, 1982.
Oil on canvas,
80 x 70 in.
(203.2 x 177.8 cm).

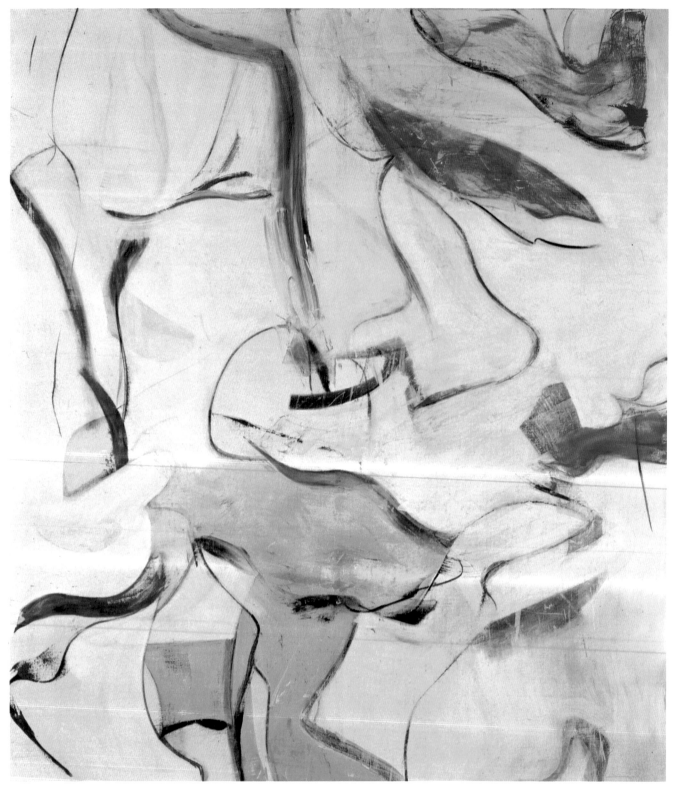

99

99.
Morning: The Springs,
1983.
Oil on canvas,
80 × 70 in.
(203.2 × 177.8 cm).

114

100

100.
Untitled XVII, 1984.
Oil on canvas,
80 × 70 in.
(203.2 × 177.8 cm).

101

101.
Untitled I, 1985.
Oil on canvas,
70 × 80 in.
(177.8 × 203.2 cm).

had by the late seventies gripped the distant past with acute accuracy even as it began to relinquish more recent events. In the eighties the promptings of visual cues seem to have tapped domains of recollection otherwise unreachable. Throughout a dinner in Springs, the identity of Max Margulis, friend since the thirties and portrait subject in the forties, eluded de Kooning. But, as Hayden Herrera recounts the story, when the artist began to sketch the face of his visitor, recognition welled up: "Oh, Max! It's you!"[157] By the end of the decade forgetfulness was enveloping. A conservatorship was established, with his daughter Lisa de Kooning and his lawyer John Eastman as co-conservators. The legal proceedings revealed the diagnosis of Alzheimer's disease. If a 1955 painting, *Interchange*, sold at auction for $20.8 million in 1989, then the issue of the artist's judgment was of more than theoretical concern. The crux of the matter was the conundrum, identified by Catherine Barnett, "of whether de Kooning's art—and all abstract expressionism, for that matter—is based on intuition or on the intellect."[158] It was a question de Kooning had pondered for half a century. It was the central theme of his work, as painting by painting he answered impulse with calculation, alternated engagement and reflection, measured advance against retreat.

That de Kooning's work in the studio was for him a means of grappling toward an understanding of human experience rather than an exercise in style seems certain. "Style is a fraud," he had insisted in 1949. "It was a horrible idea of van Doesberg and Mondrian to try to force a style. . . . I think it is the most bourgeois idea to think one can make a style beforehand. To desire to make a style is an apology for one's anxiety."[159] "In the end, naturally, it's wonderful to be admired or respected," de Kooning mused some years later. "It is part of oneself, you know . . . to be recognized as the work of a particular artist, . . . his style, his personality, his individuality. But that's the very thing this is against you—it is a sickening thing, where the thing doesn't get free of you. I said it was like having a rat in the room—they're always walking there back and forth or around the baseboard."[160]

From the pentimental poses and errant line of the thirties to the abraded layers and sinuous contours at the start of the eighties, de Kooning had acted out the jostling interplay of opposing energies. True to the resolve of the forties, he spent a lifetime demonstrating, not depicting, what he meant, the insistent imagery of carnal form cast within the palpable physicality of paint. Faced with "the misery of the scientists' space"—its "billions and billions of hunks of matter . . . floating around in darkness according to a great design of aimlessness"—de Kooning turned to the earthenness and pathos of the flesh: "If I stretch my arms next to the rest of myself," he determined, "and wonder where my fingers are—that is all the space I need as a painter."[161]

102

102.
[No title], 1986.
Oil on canvas,
80 x 70 in.
(203.2 x 177.8 cm).

118

NOTES

Interviews are with the author, except as otherwise noted.

1. The route from Virginia to Hoboken was fairly elaborate, via boat and land to Boston, Rhode Island, and Manhattan, and from there to New Jersey on a ferry. (See "Conversation with Willem de Kooning" in Bert Schierbeek, *Willem de Kooning*, exhib. cat., Stedelijk Museum [Amsterdam, 1968], unpaginated. See also Ken Wilkie, "Willem de Kooning: Portrait of a Modern Master," *Holland Herald* 17 [March 1982], 28.)

2. Interview with Willem de Kooning, Springs, New York, October 14, 1976.

3. Interview with Rudolph Burckhardt, New York, New York, November 30, 1977.

4. Willem de Kooning quoted in David L. Shirey, "Don Quixote in Springs," *Newsweek* 70 (November 20, 1967), 80.

5. I am indebted to the Willem de Kooning office in New York for the discovery of this connection. Gary Garrels considers the relationship of this pair of works of the sixties and eighties in "Three Toads in the Garden: Line, Color, and Form" (*Willem de Kooning: The Late Paintings, The 1980s*, exhib. cat., San Francisco Museum of Modern Art and Walker Art Center, Minneapolis [1995], 24).

6. Willem de Kooning quoted in Irving Sandler, "Conversations with de Kooning" (April 25, 1957 and June 16, 1959), *Art Journal* 48 (Fall 1989), 216. Mark Rothko, "The Romantics Were Prompted..." *Possibilities* 1 (Winter 1947/48), 84.

7. "Content Is a Glimpse..." excerpts from an interview with David Sylvester broadcast December 30, 1960 by B.B.C., published in *Location* 1 (Spring 1963), reprinted in Thomas B. Hess, *Willem de Kooning* (New York: Museum of Modern Art, 1968), 148.

8. The phrase is artist Robert Irwin's, from an interview in San Diego, California, summer 1992.

9. David Sylvester, *Interviews with Francis Bacon, 1962–1979* (London: Thames and Hudson, 1980), 134.

10. See Soren Kierkegaard, *Concluding Unscientific Postscript*, quoted in Lillian Marvin Swenson, preface to *Either/Or*, vol. 1, trans. David F. Swenson and Lillian Marvin Swenson (Garden City, N.Y.: Doubleday, 1959), xi.

11. Interview with Willem de Kooning, October 14, 1976.

12. Ibid., and interview with Willem de Kooning, Springs, New York, March 27, 1977. As early as February 1930 "Original African Masks and Fetiches from the Collection of John Graham and Frank Crowninshield" were exhibited at Dudensing. (See *Parnassus* 2 [February 1930], 42.)

13. "Content Is a Glimpse..." 147.

14. Interview with Elaine de Kooning, East Hampton, New York, August 5, 1979.

15. Harold Rosenberg, *Arshile Gorky* (New York: Horizon, 1962), 66.

16. See David Smith on Romany Marie's as a "hangout," quoted in *The 30s: Painting in New York*, ed. Patricia Passlof, exhib. cat., Poindexter Gallery (New York, 1957), unpaginated.

17. Max Weber, "The Artist, His Audience, and Outlook," *First American Artists' Congress* (New York, 1936), 3, quoted in Serge Guilbaut, *How New York Stole the Idea of Modern Art*, trans. Arthur Goldhammer (Chicago: University of Chicago Press, 1983), 20.

18. Jacob Kainen, "Memories of Arshile Gorky," *Arts Magazine* 50 (March 1976), 96.

19. Interview with Elaine de Kooning, August 5, 1979.

20. "Content Is a Glimpse..." 147.

21. Rudy Burckhardt, "Long Ago with Willem de Kooning," *Art Journal* 48 (Fall 1989), 224.

22. Quoted in Sandler 1989, 216.

23. John Graham, *System and Dialectics of Art* (New York: Delphic Studios, 1937), 95–96, 117.

24. Burckhardt, 224. For a consideration of de Kooning's paintings and *The Studio*, see Sally Yard, "The One Wind and *The Studio*: Willem de Kooning in the Thirties," *The Picker Art Gallery Journal* 3, no. 3 (1992), 5–13.

25. Hess 1968, 12. See Curtis Bill Pepper, "The Indomitable de Kooning," *New York Times Magazine*, November 20, 1983, 70.

26. Interview with Willem de Kooning, October 14, 1976. Elaine de Kooning remembered in the August 5, 1979 interview that de Kooning sometimes worked from photographs of the artist made by his friend Pitt Auerbach. Willem observed, the same day (in Springs), that he drew most of the men from life, usually studying his own image in one or two mirrors.

27. Harry F. Gaugh, *Willem de Kooning* (New York: Abbeville, 1983), 14.

28. Edwin Denby, "My Friend de Kooning," *Art News Annual* 29 (1963), 84, 91–92; Thomas B. Hess, *Willem de Kooning* (New York: Braziller, 1959), 21–22; and interviews with Elaine de Kooning and Willem de Kooning, August 5, 1979.

29. Denby 1963, 88.

30. Burckhardt, 223.

31. Joseph Liss, "Willem de Kooning Remembers Mark Rothko: 'His house had many mansions'," *ARTnews* 78 (January 1979), 41.

32. De Kooning called the work "staggering" in the film *De Kooning on de Kooning*, directed by Charlotte Zwerin, produced by Courtney Sale (New York, 1981).

33. Elaine de Kooning's observation that the exhibition was "prodigiously important" (interview, August 5, 1979) echoed Willem's account (interview, October 14, 1976). *Les Demoiselles d'Avignon* joined the collection of the Museum of Modern Art in 1939 through the Lillie P. Bliss bequest. Robert Rosenblum has elucidated the stunning relationship of de Kooning's work to Picasso. See, for example, "The Fatal Women of Picasso and de Kooning," *ARTnews* 84 (October 1985), 98–103.

34. Interview with Willem de Kooning, August 5, 1979.

35. Interview with Thomas Hess, December 5, 1977, New York, New York; and interview with Elaine de Kooning, August 5, 1979.

36. The exhibition at the Valentine Gallery was arranged by the American Artists' Congress.

37. Burckhardt, 224.

38. Edwin Denby, "Willem de Kooning," *Dancers, Buildings and People in the Streets* (New York: Horizon, 1965), 267.

39. Ibid., 268, and interview with Elaine de Kooning, August 5, 1979.

40. Denby 1963, 87–88. See Sally Yard, "Willem de Kooning's Women," *Arts Magazine* 53 (November 1978), cover, 96–101.

41. It was Sam Hunter who made this connection, in correspondence of October 27, 1979. Three of Picasso's *Weeping Women* were included in the Museum of Modern Art's 1939 Picasso exhibition.

42. "Congenial Company," *Art Digest* 16 (January 15, 1942), 18.

43. Graham's four-page statement, which he circulated in 1946, was made available to me by Annalee Newman during an interview in New York, New York, April 20, 1977.

44. Graham, *System and Dialectics of Art*, 75–76. Interview with Willem de Kooning, March 27, 1977.

45. Elaine de Kooning, "Artist Questionnaire," September 9, 1988, on file in Department of 20th Century Art archives, Metropolitan Museum of Art, New York, cited in Lisa Mintz Messinger, *Abstract Expressionism: Works on Paper*, exhib. cat., Metropolitan Museum of Art (New York, 1992), 22.

46. Interview with Hess, December 5, 1977; phone conversation with Edvard Lieber, August 1991; Messinger, 22.

47. Elaine de Kooning, "Artist Questionnaire," cited in Messinger, 22.

48. The phrase "subjacent animality" is Gérard Fabre's ("Between Tame Dog and Wild Wolf: A Twilight Zone," trans. R. F. M. Dexter, in *Focus on* Minotaure: *The Animal-Headed Review* [Geneva: Musée d'Art et d'Histoire, 1987], 175). Georges Bataille, "Metamorphose," *Documents* no. 6 (November 1929), quoted in Fabre, 182.

49. The word is borrowed from Leo Steinberg's essay "The Philosophical Brothel, Part 2," *ARTnews* 71 (October 1972), 43.

50. Ibid., 39.

51. Ibid., 44.

52. *The End of a Monster* was included in the 1939 Museum of Modern Art exhibition and was reproduced in the catalogue (p. 184).

53. Conversation with Willem de Kooning, Springs, New York, September 1974.

54. See Susan Lake and Judith Zilczer, "Painter and Draftsman," in Judith Zilczer, *Willem de Kooning from the Hirshhorn Museum Collection*, exhib. cat., Hirshhorn Museum and Sculpture Garden (Washington, D.C., 1993), 177.

55. Interview with Willem de Kooning, October 14, 1976. For a consideration of de Kooning's use of paper, see Thomas B. Hess, *Willem de Kooning Drawings* (Greenwich, Conn.: New York Graphic Society, 1972), 14–16.

56. Interview with Hess, December 5, 1977.

57. Judith Zilczer, "De Kooning and Urban Expressionism," in Zilczer, 33.

58. Francis Bacon, interview by Hugh Davies, April 3, 1973, quoted in Hugh Davies and Sally Yard, *Francis Bacon* (New York: Abbeville, 1986), 36. See Thomas B. Hess, *De Kooning: Recent Paintings* (New York: Walker & Co. for M. Knoedler & Co., 1967), 14–15, for a discussion of de Kooning's painting "from all sides." See Sally Yard, "The Angel and the *demoiselle*—Willem de Kooning's *Black Friday*," *Record of The Art Museum Princeton University* 50, no. 2 (1991), esp. p. 10.

59. Barnett Newman, review of *Abstract Painting: Background and American Phase* by Thomas B. Hess (1951), in *Barnett Newman: Selected Writings and Interviews*, ed. John P. O'Neill (New York: Alfred A. Knopf, 1990), 122. The review, which Newman had been invited to write for *Partisan Review*, went unpublished.

60. Willem and Elaine and Charles Egan arrived at final titles one evening as the opening approached. See Charles Stuckey, "Bill de Kooning and Joe Christmas," *Art in America* 68 (March 1980), 70–71.

61. Renée Arb, "Spotlight on: De Kooning," *ARTnews* 47 (April 1948), 33; Clement Greenberg, "Art," *Nation* 166 (April 24, 1948), 448.

62. Hess 1968, 76–77.

63. Willem de Kooning, "A Desperate View," talk delivered February 18, 1949 at the Subjects of the Artist School, published in Hess 1968, 15.

64. Robert Coates, "The Art Galleries," *The New Yorker* 22 (March 30, 1946), 75.

65. Interview with Willem de Kooning by James T. Valliere, "De Kooning on Pollock," *Partisan Review* 34 (Fall 1967), 604.

66. Willem de Kooning in *Artists' Sessions at Studio 35* (1950), ed. Robert Goodnough (New York: Wittenborn Schultz, 1951), 14.

67. Pat Passlof, "1948," *Art Journal* 48 (Fall 1989), 229.

68. Willem de Kooning quoted in Paul Brach, "Gorky's Secret Garden," *Art in America* 69 (October 1981), 122.

69. Willem de Kooning, "Letter to the Editor," *ARTnews* 47 (January 1949), 6.

70. Interview with Elaine de Kooning, August, 5, 1979.

71. Willem de Kooning, "A Desperate View," 15.

72. Willem de Kooning, "The Renaissance and Order," written in 1950 for a talk at Studio 35, published in *trans/formation* 1, no. 2 (1951), reprinted in Hess 1968, 143.

73. William Barrett, *Irrational Man* (New York: Doubleday, 1958), 247.

74. Interview with Newman, April 20, 1977; interview with Hess, December 5, 1977.

75. Open letter to Roland L. Redmond, president of the Metropolitan Museum of Art, May 20, 1950. See B. H. Friedman, "'The Irascibles': A Split Second in Art History," *Arts Magazine* 53 (September 1978), 100, 102. Interview with Newman, April 20, 1977.

76. Alfred H. Barr, Jr., "7 Americans open in Venice—Gorky, De Kooning, Pollock," *ARTnews* 49 (June 1950), 22. Barr was then director of the Museum of Modern Art's collections.

77. See Guilbaut, esp. pp. 201–05; and Irving Sandler, *The Triumph of American Painting: A History of Abstract Expressionism* (New York: Harper and Row, 1970).

78. Katharine Kuh, "The Story of a Picture," *Saturday Review* 52 (March 29, 1969), 38. Hess 1959, 20.

79. Willem de Kooning, "What Abstract Art Means to Me," written for a symposium at the Museum of Modern Art, February 5, 1951; published in *The Museum of Modern Art Bulletin* 18 (Spring 1951); reprinted in Hess 1968, 145-46. See Zilczer, 191. Ritchie was at the time director of the department of painting and sculpture at the Museum of Modern Art.

80. Thomas B. Hess, "Four Stars for the Spring Season," *ARTnews* 50 (April 1951), 24.

81. Hiram Carruthers Butler, "Downtown in the Fifties," *Horizon* 24 (June 1981), 24.

82. Willem de Kooning quoted in Valliere, 604–05.

83. Michael Leja, *Reframing Abstract Expressionism: Subjectivity and Painting in the 1940s* (New Haven: Yale University Press, 1993), see esp. pp. 109, 113.

84. Harold Rosenberg, "The American Action Painters," *ARTnews* 51 (December 1952), 22–23. In keeping with the theoretical tone of the essay, Rosenberg identified none of the "action painters" by name. Interview with Hess, December 5, 1977.

85. Although de Kooning gave Rauschenberg a drawing for the purpose, choosing one that would be difficult to erase, he was not entirely pleased with the publicity that surrounded the event. (Interviews with Willem de Kooning, October 14, 1976 and March 27, 1977.)

86. See Robert Storr, "No Joy in Mudville: Greenberg's Modernism Then and Now," in *Modern Art and Popular Culture: Readings in High and Low*, ed. Kirk Varnedoe and Adam Gopnik (New York: Museum of Modern Art and Harry N. Abrams, 1990), 178.

87. Peter Brooks, *Body Work: Objects of Desire in Modern Narrative* (Cambridge, Mass.: Harvard University Press, 1993), 257–58.

88. Hess 1959, 21, pointed out the T-zone source of the smile. *The Dance* was included in the 1939 Museum of Modern Art exhibition and reproduced in the catalogue (p. 124).

89. Storr, 178.

90. See Hess 1972, 18.

91. The connection was discussed by Thomas B. Hess in *Places—Aaron Siskind Photographs* (New York: Light Gallery and Farrar Straus and Giroux, 1976), 6–7.

92. Willem de Kooning quoted in Zilczer, "De Kooning and Urban Expressionism," 47. The remark originally was published in Margaret Staats and Lucas Matthiessen, "The Genetics of Art," *Quest* 77 (March-April 1977), 70.

93. In the December 5, 1977 interview, Thomas Hess was clear that his previous accounts had been in error, and that in fact not a single stroke was added to *Woman I* after Meyer Schapiro's visit. See, for example, Thomas B. Hess, "De Kooning Paints a Picture," *ARTnews* 52 (March 1953), 30.

94. See Sigmund Freud, "Fragment of an Analysis of a Case of Hysteria" (1905), *Dora: An Analysis of a Case of Hysteria*, ed. Philip Rieff (New York: Macmillan, 1963), 102–03.

95. Willem de Kooning quoted in George Dickerson, "The Strange Eye and Art of de Kooning," *Saturday Evening Post*, November 21, 1964, reprinted in *The Collected Writings of Willem de Kooning* (New York: Hanuman, 1988), 124. The T-zone ads appeared with regularity on the back cover of *Time* magazine in the late forties.

96. Hubert Crehan, "A See Change: Woman Trouble," *Art Digest* 27 (April 15, 1953), 5.

97. Sidney Geist, "Work in Progress," *Art Digest* 27 (April 1, 1953), 15.

98. James Fitzsimmons, "Art," *Arts and Architecture* 70 (May 1953), 4, 6.

99. "Content Is a Glimpse..." 148–49.

100. Stuckey, 67. De Kooning's interest in *Bitter Rice* had been discussed with Katharine Kuh (p. 38). "The wet fields with peasants spading up and into the rich loam" is her paraphrase.

101. Fred Lawrence Guiles, *Legend: The Life and Death of Marilyn Monroe* (New York: Stein and Day, 1984), 248. See also J. Hoberman, "American Myths: Marilyn Monroe," *Artforum* 32 (January 1994), 11.

102. Marilyn Monroe quoted in David McCarthy, "Tom Wesselmann and the Americanization of the Nude," *Smithsonian Studies in American Art* 4 (Summer/Fall 1990), 120–21.

103. Jane Bowles, *Two Serious Ladies* (1943) (New York: E. P. Dutton, 1984), 201. De Kooning discussed his enthusiasm for the work of Bowles, Faulkner, and Dostoevsky during the October 14, 1976; March 27, 1977; and August 5, 1979 interviews.

104. De Kooning spoke of his interest in the Stein operas, staged in collaboration with Virgil Thomson, reporting that he had seen *Four Saints in Three Acts* performed once, and *The Mother of Us All* twice. (Interviews with Willem de Kooning, October 14, 1976 and March 27, 1977.)

105. Lisa Ruddick, *Reading Gertrude Stein* (Ithaca, N.Y.: Cornell University Press, 1990), 207–08.

106. Brian O'Doherty, "Willem de Kooning: Fragmentary Notes Towards a Figure," *Art International* 12 (December 20, 1968), 25.

107. Kirsten Hoving Powell worked out the details of *Easter Monday*'s date of completion. I am indebted to her exhaustive search of the offset imagery. ("Resurrecting Content in de Kooning's *Easter Monday*," *Smithsonian Studies in American Art* 4 [Summer/Fall 1990], 86–101.) See Hess 1968, 50.

108. Quoted in Schierbeek, unpaginated.

109. See David Rosand's consideration of the "Vitruvian" reach of the artist in "Proclaiming flesh," *Times Literary Supplement*, February 17, 1984, 167.

110. Hess 1968, 103.

111. "Content Is a Glimpse..." 149.

112. Gaugh, 64, 66.

113. Dore Ashton, "Willem de Kooning," *Arts and Architecture* 76 (July 1959), 30. See also Hess 1968, 101.

114. "Big Splash," *Time* 73 (May 18, 1959), 72.

115. Statement by Robert Rauschenberg in *Art Journal* 48 (Fall 1989), 232. I am indebted to Robert Irwin's insight into de Kooning's impact. (Interview with Irwin, summer 1992.)

116. Quoted in G. R. Swenson, "What Is Pop Art?" *ARTnews* 62 (February 1964), 64.

117. Willem de Kooning, talking with friends in 1959, in Robert Snyder's film *A Glimpse of de Kooning* (1968). For a transcript of the discussion, see *Willem de Kooning: Écrits et propos*, ed. Marie-Anne Sichère (Paris, 1992), 45–54.

118. Hess 1972, 48–49.

119. Harold Rosenberg, "Interview with Willem de Kooning," *ARTnews* 71 (September 1972), 57.

120. Herman Cherry, "Willem de Kooning," *Art Journal* 48 (Fall 1989), 230.

121. Ibid.

122. See Schierbeek, unpaginated.

123. Interview with Willem de Kooning, October 14, 1976.

124. Quoted in Schierbeek, unpaginated.

125. That a process of tracing was enlisted is clear; the identical positioning of a variety of passages would otherwise be extraordinary, though of course there are differences as well. The drawing in the collection of the Hirshhorn Museum and Sculpture Garden apparently was made after the image in the collection of the Museum of Contemporary Art, San Diego.

126. Willem de Kooning quoted in Judith Wolfe, "Glimpses of a Master," *Willem de Kooning: Works from 1951–1981*, exhib. cat., Guild Hall Museum (East Hampton, N.Y., 1981), 14.

127. Quoted in Zilczer, "De Kooning and Urban Expressionism," 56.

128. Georges Duthuit, "Matisse and Byzantine Space," *Transition* 49 no. 5 (1949), 30. De Kooning spoke of his admiration for this essay in the interview of October 14, 1976. De Kooning's association of the paintings with Byzantine saints was noted in a conversation of September 1974 and in Hess 1967, 24. The idea of arranging the paintings "flush together" was noted by Thomas B. Hess, "De Kooning's new Women," *ARTnews* 64 (March 1965), 65.

129. A letter of October 24, 1964, from dealer Harold Diamond (to the original collector of the work now in the Museum of Contemporary Art, San Diego) reported that the new paintings and the two drawings that took their dimensions from doors "are variations on one theme, a woman in a rowboat, lying on her back." Diamond sold both drawings, the other to Joseph Hirshhorn.

130. *Woman with Her Throat Cut* was acquired by the Museum of Modern Art in 1949.

131. "Prisoner of the Seraglio," *Time* 85 (February 26, 1965), 74.

132. See Hess 1967, 34.

133. Quoted in Charlotte Willard, "In the Art Galleries," *New York Post Magazine*, August 23, 1964, 44.

134. Bowles, 98.

135. William Faulkner, *Requiem for a Nun* (1950) (New York: Random House, 1951), 225. De Kooning spoke of *Requiem for a Nun* in the March 27, 1977 interview. See Stuckey's provocative consideration of de Kooning's *Light in August* (c. 1946): "Bill de Kooning and Joe Christmas," 66–79.

136. Soren Kierkegaard, *The Concept of Anxiety*, ed. and trans. Reidar Thomte in collaboration with Albert B. Anderson (Princeton: Princeton University Press, 1980), 45. In the October 14, 1976 interview, de Kooning discussed Kierkegaard.

137. C. G. Jung, *The Archetypes and the Collective Unconscious*, second edition, trans. R. F. C. Hull (Princeton: Princeton University Press, 1969), 82.

138. C. G. Jung, *Symbols of Transformation*, second edition, trans. R. F. C. Hull (Princeton: Princeton University Press, 1967), 263.

139. Interview with Elaine de Kooning, August 5, 1979.

140. Rosenberg 1952, 23.

141. Willem de Kooning 1949, 15.

142. Faulkner, *Requiem for a Nun*, 183.

143. See Yve-Alain Bois, *Painting as Model* (Cambridge, Mass.: M. I. T. Press, 1990), esp. p. 257.

144. Harold Rosenberg, "The Diminished Act," *Act and the Actor: Making the Self* (New York: World Publishing Company, 1970), esp. pp. 5–6. De Kooning discussed his interest in this passage during the October 14, 1976 interview. See also "Guilt to the Vanishing Point" in the same volume, esp. pp. 193–94.

145. Conversation with Willem de Kooning, September 1974. A kindred voicing of the worrisome nature of retrospectives had been quoted in Hess 1968, 11; and in "De Kooning's Year," *Newsweek* 73 (March 10, 1969), 88. It was de Kooning's faith in the poet Frank O'Hara, a curator at the Museum of Modern Art, that initially persuaded the artist to undertake the exhibition. (Hess 1968, 11.)

146. Emily Genauer, "De Kooning's Complaint," *Newsday*, March 8, 1969, 14W, 17W.

147. *De Kooning Drawings* (New York: Walker, 1967), unpaginated.

148. Peter Schjeldahl, "De Kooning's Sculpture," in Philip Larson and Peter Schjeldahl, *De Kooning: drawings/sculptures* (New York: E. P. Dutton, 1974), unpaginated.

149. Interview with Willem de Kooning, October 14, 1976; conversation in the Willem de Kooning office, New York, July 1993.

150. De Kooning's remark was recorded in the film *Willem de Kooning and the Unexpected*, produced by Erwin Leiser Filmproducktion (Zurich, 1979).

151. Robert Creeley, "Bill the King" (1979), *Art Journal* 48 (Fall 1989), 238.

152. Willem de Kooning in Rosenberg 1972, 58.

153. Ibid., 57.

154. Willem de Kooning quoted in Hess 1967, 24.

155. Rosand, 167. See Gaugh's discussion (pp. 104, 113–14) of the Keats reference.

156. Vivien Raynor, "Art: Recent Koonings," *New York Times*, June 8, 1984, section 3, 24.

157. Hayden Herrera, "Willem de Kooning: A Space Odyssey," *Harper's Bazaar* no. 3389 (April 1994), 195.

158. Catherine Barnett, "The Conundrum of Willem de Kooning," *Art and Antiques* 6 (November 1989), 70.

159. Willem de Kooning 1949, 15.

160. Willem de Kooning in Zwerin and Sale. This particular passage was apparently drawn from earlier footage.

161. Willem de Kooning 1951, 146.

CHRONOLOGY

1904

Born in Rotterdam, the Netherlands, April 24.

1926

Emigrated to the United States. Lived for a few months in Hoboken.

1927

Settled in Manhattan.

1962

Became a U.S. citizen.

1963

Moved to Springs, Long Island.

1997

Died in Springs, March 19.

Selected One-Person Exhibitions

Only exhibition titles other than *Willem de Kooning* and *De Kooning* are noted.

1948

Egan Gallery, New York, April 12–30.

1951

Egan Gallery, New York, April 1–30. Traveled to Arts Club of Chicago.

1953

Willem de Kooning: Paintings on the Theme of the Woman, Sidney Janis Gallery, New York, March 16–April 11.

De Kooning: 1935–1953. School of the Museum of Fine Arts, Boston, April 21-May 8. Traveled to Workshop Art Center, Washington, D.C. Catalogue by Clement Greenberg.

1955

Recent Oils by Willem de Kooning, Martha Jackson Gallery, New York, November 9–December 3. Catalogue by Kenneth B. Sawyer.

1956

Sidney Janis Gallery, New York, April 2–28.

1959

Sidney Janis Gallery, New York, May 5–30.

1961

Paul Kantor Gallery, Beverly Hills, April 3–29. Catalogue by Clifford Odets.

1962

Recent Paintings by Willem de Kooning, Sidney Janis Gallery, New York, March 5–31. Catalogue by Thomas B. Hess.

1964

"Woman" Drawings by Willem de Kooning, James Goodman Gallery, Buffalo, January 10–25. Catalogue by Merle Goodman.

Willem de Kooning Retrospective: Drawings 1936–1963, Allan Stone Gallery, New York, February 1–29. Catalogue.

1965

Paul Kantor Gallery, Beverly Hills, March 22–April 30. Traveled to Aspen Institute. Catalogue by William Inge.

Smith College Museum of Art, Northampton, April 8–May 2. Traveled to Hayden Gallery, Massachusetts Institute of Technology, Cambridge. Catalogue by Dore Ashton.

1966

De Kooning's Women, Allan Stone Gallery, New York, March 14–April 2. Catalogue.

1967

De Kooning: Recent Paintings, M. Knoedler and Co., New York, November 14–December 2. Catalogue by Thomas B. Hess.

1968

Willem de Kooning: Three Decades of Painting, J. L. Hudson Gallery, Detroit, March 19–April 13.

De Kooning: Peintures récentes, M. Knoedler and Co., Paris, June 4–29. Catalogue by Thomas B. Hess.

Stedelijk Museum, Amsterdam, September 19–November 17. Traveled to Tate Gallery, London; Museum of Modern Art, New York; Art Institute of Chicago; Los Angeles County Museum of Art. Organized by the Museum of Modern Art, New York. Catalogues (Amsterdam) by Thomas B. Hess, Bert Schierbeek, and Edy de Wilde; and (New York and London) by Thomas B. Hess.

1969

Willem de Kooning: Disegni. XII Festival dei Due Mondi. Palazzo Ancaiani, Spoleto, June 28–July 13. Catalogue by Giovanni Carandente.

De Kooning: The Recent Work. Powerhouse Gallery, University Art Museum, University of California, Berkeley, August 12–September 14.

1971

Willem de Kooning: The 40s and 50s, Allan Stone Gallery, New York, October 17–November 1.

Seven by de Kooning, Museum of Modern Art, New York, December 30–February 28, 1972.

1972

Willem de Kooning: Paintings, Sculpture, Works on Paper, Baltimore Museum of Art, August 8–September 24.

An Exhibition by de Kooning Introducing His Sculpture and New Paintings, Sidney Janis Gallery, October 4–November 4.

Willem de Kooning: Selected Works, Allan Stone Gallery, New York, October 17–November 11.

Lithographs by Willem de Kooning, American Center, Tokyo, November 14–24.

1973

Willem de Kooning: Paintings, Drawings, Sculpture, Gertrude Kasle Gallery, Detroit, May 19–June 30.

Collection d'Art Galerie I, Amsterdam, November 3–December 6.

1974

De Kooning: Drawings/Sculptures, Walker Art Center, Minneapolis, March 10-April 21. Traveled to National Gallery of Canada, Ottawa; Phillips Collection, Washington, D.C.; Albright-Knox Art Gallery, Buffalo; Museum of Fine Arts, Houston; Washington University Gallery of Art, Saint Louis. Catalogue by Philip Larson and Peter Schjeldahl.

Willem de Kooning: Grafiken 1970/71, Galerie Biedermann, Munich, September 26-November 9.

Willem de Kooning, 1941-1959, Richard Gray Gallery, Chicago, October 4-November 16. Catalogue.

1975

Fuji Television Gallery, Tokyo, September 5-October 4. Catalogue by Sam Hunter and Yoshiaki Tono.

De Kooning: New Works—Paintings and Sculpture, Fourcade, Droll, New York, October 25-December 6.

Galerie des Arts, Paris, October 29-November 29. Catalogue by Sam Hunter.

Willem de Kooning: Matrix 15, Wadsworth Atheneum, Hartford, December-January 1976. Catalogue by Andrea Miller Keller.

De Kooning: Paintings, Drawings, Sculptures, 1967-75, Norton Gallery of Art, West Palm Beach, December 10-February 15, 1976. Catalogue.

1976

De Kooning: New Paintings and Sculpture, Seattle Art Museum, February 4-March 14. Catalogue.

Collection d'Art Galerie I, Amsterdam, May 1-July 1. Catalogue by Dolf Welling.

Willem de Kooning: Paintings, Drawings, Sculptures, James Corcoran Gallery, Los Angeles, May 20-June 26.

Willem de Kooning: Recent Paintings, Gimpel Fils, London, June 29-August 12. Traveled to Gimpel and Hanover, Zurich.

De Kooning: New Paintings, 1976, Xavier Fourcade, New York, October 12-November 20.

1977

Willem de Kooning: Peintures et sculptures recentes, Galerie Templon, Paris, September 15-October 30.

Willem de Kooning: Paintings and Sculpture, Museum of Contemporary Art, Belgrade, October 1-December 1. Traveled to Museum of Modern Art, Ljubljana, Yugoslavia; Romanian National Museum of Art, Bucharest; National Museum, Warsaw; Branch Post, Krakow, Poland; Helsinki National Museum of Art; Amerika Haus, East Berlin; Caja de Ahorros, Alicante, Spain; Fundación Juan March, Madrid; Oslo Nasjonalgalleriet; and Dordrechts Museum, The Netherlands. Organized by the United States Information Agency and Hirshhorn Museum and Sculpture Garden. Catalogues by Abram Lerner.

De Kooning: New Paintings, 1977, Xavier Fourcade, New York, October 11-November 19.

The Sculptures of de Kooning with Related Paintings, Drawings, and Lithographs, Fruit Market Gallery, Edinburgh, October 15-November 12. Traveled to Serpentine Gallery, London. Organized by the Arts Council of Great Britain. Catalogue by David Sylvester and Andrew Forge.

Willem de Kooning: Recent Works, James Corcoran Gallery, Los Angeles, November 11-December 5.

1978

Willem de Kooning in East Hampton, Solomon R. Guggenheim Museum, New York, February 10-April 23. Catalogue by Diane Waldman.

Helsingin Kaupungin Taidekokoelmat, Helsinki, March 6-April 22. Catalogue by Marja-Liisa Bell.

Willem de Kooning: Matrix 12, University Art Museum, University of California, Berkeley, August 30-October 29. Catalogue by Andrea Miller Keller.

De Kooning, 1969-78, University of Northern Iowa Gallery of Art, Cedar Falls, October 21-November 26. Traveled to St. Louis Art Museum; Contemporary Arts Center, Cincinnati; Akron Art Institute. Catalogue by Jack Cowart and Sanford Sivitz Shaman.

1979

Willem de Kooning: New Paintings, 1978-1979, Xavier Fourcade, New York, October 20-November 17.

Willem de Kooning: Pittsburgh International Series, Museum of Art, Carnegie Institute, Pittsburgh, October 26-January 6, 1980. Catalogue by Leon Arkus.

1980

Willem de Kooning: Paintings, Sculpture, Drawings, Richard Hines Gallery, Seattle, January 23-March 8.

Hans Strelow Gallery, Dusseldorf, November.

1981

Willem de Kooning: Works from 1951-1981, Guild Hall Museum, East Hampton, May 23-July 19. Catalogue by Judith Wolfe.

1982

Willem de Kooning: Paintings and Drawings, C. Grimaldis Gallery, Baltimore, February 3-28.

Willem de Kooning: New Paintings, 1981-1982, Xavier Fourcade, New York, March 17-May 1.

1983

Willem de Kooning: The North Atlantic Light, 1960-1983, Stedelijk Museum, Amsterdam, May 10-July 3. Traveled to Louisiana Museum, Humlebaek, Denmark; Moderna Museet, Stockholm. Catalogue by Edy de Wilde and Carter Ratcliff.

Willem de Kooning: The Complete Sculpture, 1969-1983, Xavier Fourcade, New York, May 14-June 30.

The Drawings of Willem de Kooning, Whitney Museum of American Art, New York, December 7-February 19, 1984. Traveled and shared catalogues with concurrent *Willem de Kooning Retrospective Exhibition*.

Willem de Kooning Retrospective Exhibition, Whitney Museum of American Art, New York, December 15-February 26, 1984. Traveled to Akademie der Kunste, West Berlin; Musée national d'art moderne, Centre Georges Pompidou, Paris. Two catalogues: one by Paul Cummings, Jorn Merkert, and Claire Stoullig (New York and Munich); the other by Dominique Bozo, Claire Stoullig, et al (Paris).

1984

Willem de Kooning: New Paintings, Sculpture, and Drawings, Xavier Fourcade, New York, May 12-June 23. Catalogue.

Willem de Kooning: Paintings and Sculpture, 1971-1983, Anthony d'Offay Gallery, London, November 21-January 11, 1985. Catalogue.

1985

De Kooning: Dipinti, disegni, sculture, Studio Marconi, Milan, March-April. Catalogue by Attilo Codognato.

Willem de Kooning: New Paintings, 1984-1985, Xavier Fourcade, New York, October 17-November 16. Catalogue.

1986

Willem de Kooning: Recent Paintings, 1983-1986, Anthony d'Offay Gallery, London, November 21-January 14, 1987. Catalogue by Robert Rosenblum.

1987

Willem de Kooning: Abstract Landscapes, 1955-1963, Gagosian Gallery, New York. Catalogue by Henry Geldzahler.

1990

Galerie Karsten Greve, Cologne, February 8-28. Traveled to Galerie Karsten Greve, Paris, March 8-April 18. Catalogue.

Willem de Kooning: Works on Paper, 1954–1984, organized by Contempo Modern Art Gallery, Eindhoven, for European Art Fair, Mastricht, March 10–18, and Tokyo Art Expo, Harumi International Trade Center, March 29–April 2. Catalogue by Annelette Hamming.

Willem de Kooning: An Exhibition of Paintings, Salander O'Reilly Galleries, New York, September 4–October 15. Catalogue by Klaus Kertess and Robert Rosenblum.

Willem de Kooning/Jean Dubuffet: The Women, Pace Gallery, New York, November 30–January 5, 1991. Catalogue by Mildred Glimcher.

1991

Willem de Kooning: A Selection of Printer's Proofs from the Collection of Irwin Hollander, Master Printer, Meredith Long and Co., Houston, October 22–November 23. Traveled to Salander-O'Reilly Galleries, Beverly Hills; Galeria Afinsa, Madrid; Salander-O'Reilly Galleries, Berlin; Salander-O'Reilly Galleries, New York. Catalogue by Lanier Graham, et al.

1993

Willem de Kooning: Transcending Landscape, Paintings, 1975–1979, C & M Arts, New York, March 4–April 24. Catalogue by° Jill Weinberg Adams.

Willem de Kooning from the Hirshhorn Museum Collection, Hirshhorn Museum and Sculpture Garden, Washington, October 21–January 9, 1994. Traveled to Fundació "la Caixa," Centre Cultural, Barcelona; High Museum of Art, Atlanta; Museum of Fine Arts, Boston; Museum of Fine Arts, Houston. Catalogue by Judith Zilczer, Lynne Cooke, and Susan Lake.

1994

Willem de Kooning Paintings, National Gallery of Art, Washington, D.C., May 8–September 5. Traveled to Metropolitan Museum of Art, New York; Tate Gallery, London. Catalogue by Marla Prather, Richard Shiff, and David Sylvester.

Willem de Kooning: A Summer Exhibition, Selected Works 1950s–1980s, C & M Arts, New York, June 7–August 12.

Celebrating Willem de Kooning: Selected Paintings and Sculpture, Guild Hall Museum, East Hampton, June 25–July 31. Catalogue by Klaus Kertess.

Willem de Kooning: Liquefying Cubism, Allan Stone Gallery, New York, October 7–January 8, 1995. Catalogue by Allan Stone.

1995

De Kooning: The Women/Works on Paper 1947–1954, C & M Arts, New York, September 19–November 18. Catalogue by Diane Waldman.

Willem de Kooning: The Late Paintings, The 1980s, San Francisco Museum of Modern Art, October 3–January 7, 1996. Catalogue by Gary Garrels and Robert Storr. Traveled to Walker Art Center, Minneapolis; Stadtisches Kunstmuseum, Bonn; Museum Boymans-van Beuningen, Rotterdam; Museum of Modern Art, New York.

Willem de Kooning's Door Cycle, Davis Museum and Cultural Center, Wellesley College, October 12–February 26, 1996. Traveled to Whitney Museum of American Art, New York.

Willem de Kooning in Seattle: Selected Works from 1943 to 1985 in Public and Private Collections, Seattle Art Museum, November 2–March 3, 1996.

1996

Willem de Kooning: Paintings 1982–1986, C & M Arts, New York, April 4–June 1. Catalogue.

SELECTED BIBLIOGRAPHY

Statements and Writings by the Artist

Listed chronologically

Letter to the editor about Arshile Gorky. *ARTnews* 47 (January 1949): 6.

"A Desperate View" (talk delivered at the Subjects of the Artist School, New York, February 18, 1949). Published in Thomas B. Hess. *Willem de Kooning.* New York: Museum of Modern Art, 1968, 15-16.

"The Renaissance and Order" (talk delivered in 1950 at Studio 35, New York). *trans/formation* 1 (1951): 85-87.

"What Abstract Art Means to Me" (statement written for a symposium at the Museum of Modern Art, New York, February 5, 1951). *Museum of Modern Art Bulletin* 18 (Spring 1951): 4-8.

"Content Is a Glimpse..." *Location* 1 (Spring 1963): 45-53. Excerpts from an interview by David Sylvester. "Painting as Self-Discovery." BBC broadcast, December 30, 1960.

The Collected Writings of Willem de Kooning. Edited by George Scrivani. Madras and New York: Hanuman, 1988.

Interviews and Transcribed Discussions

Listed chronologically

"Artists' Sessions at Studio 35 (1950)." Edited by Robert Goodnough. *Modern Artists in America.* New York: Wittenborn Schultz, 1951.

De Hirsch, Storm. "A Talk with de Kooning." *Intro Bulletin* 1 (October 1955): 1-3.

Rodman, Selden. "Willem de Kooning." *Conversations with Artists.* New York: Devan Adair, 1957.

Hess, Thomas B. "Is Today's Artist With or Against the Past?" *ARTnews* 57 (Summer 1958): 27, 56.

Sketchbook no. 1: Three Americans. Film Script. New York: Robert Snyder and Time-Life Films, 1960.

Valliere, James T. "De Kooning on Pollock." *Partisan Review* 34 (Fall 1967): 603-05.

Sandler, Irving. "Willem de Kooning: Gesprek in de Kooning's atelier, 16 juni 1959." *Museumjournaal* 13 (1968): 285-90, 336.

Schierbeek, Bert. "Willem de Kooning." *Willem de Kooning.* Exh. cat., Stedelijk Museum. Amsterdam, 1968.

Mooradian, Karlen. "Interview with Willem de Kooning, July 19, 1966." *Ararat* 12 (Fall 1971): 48-52.

Rosenberg, Harold. "Interview with Willem de Kooning." *ARTnews* 71 (September 1972): 54-59.

Hunter, Sam. "De Kooning: 'Je dessine les yeux fermés.'" *Galerie Jardin des Arts* no. 152 (November 1975): 68-70.

Staats, Margaret, and Lucas Matthiessen. "The Genetics of Art: Willem de Kooning." *Quest* 77 (March/April 1977): 70-71.

Liss, Joseph. "Willem de Kooning Remembers Mark Rothko: 'His house had many mansions.'" *ARTnews* 78 (January 1979): 41-44.

De Antonio, Emile, and Mitch Tuchman. *Painters Painting.* New York: Abbeville, 1984.

Willem de Kooning: Ecrits et propos. Edited by Marie-Anne Sichère. Paris: Ecole nationale superieure des Beaux-Arts, 1992.

Books

Cateforis, David. *Willem de Kooning.* New York: Rizzoli, 1994.

De Kooning Drawings. New York: Walker, 1967.

Denby, Edwin. "Willem de Kooning." *Dancers, Buildings and People in the Streets,* New York: Horizon, 1965.

————. *Willem de Kooning.* Madras and New York: Hanuman, 1988.

Drudi, Gabriella. *Willem de Kooning.* Milan: Fabbri, 1972.

Gaugh, Harry F. *Willem de Kooning.* New York: Abbeville, 1983.

Graham, Lanier. *The Prints of Willem de Kooning: A Catalogue Raisonné, 1957-1971.* Vol. 1. Paris: Baudoin Lebon, 1991.

Hess, Thomas B. *Willem de Kooning.* New York: Braziller, 1959.

————. *Willem de Kooning Drawings.* Greenwich, Conn.: New York Graphic Society, 1972.

Janis, Harriet, and Rudi Blesh. *De Kooning.* New York: Grove, 1960.

Rosenberg, Harold. *De Kooning.* New York: Abrams, 1974.

Sollers, Philippe. *De Kooning, Vite.* Paris: Editions de la Différence, 1988.

Waldman, Diane. *Willem de Kooning.* New York: Abrams; Washington, D.C.: National Museum of American Art, 1988.

Yard, Sally. *Willem de Kooning: The First Twenty-Six Years in New York, 1927-1952.* New York: Garland, 1986.

LIST OF ILLUSTRATIONS

All works are by Willem de Kooning, except as otherwise noted.

Height precedes width precedes depth.

1. *Still Life*, 1927.
Oil on canvas,
32 ¹/₈ × 24 in. (81.5 × 61 cm).
Collection of the artist.
Photo: Christopher Burke,
Quesada/Burke, New York.

2. *Untitled*, c. 1931.
Oil on canvas,
23 ⁷/₈ × 33 in. (60.6 × 83.8 cm).
Private collection.

3. *Father, Mother, Sister, and Brother*,
c. 1937.
Oil on board,
12 × 22 ¹/₂ in. (30.5 × 57.1 cm).
Courtesy Allan Stone Gallery,
New York.

4. *Untitled*, 1939–40.
Oil on mat board,
8 ¹/₂ × 12 ¹/₄ in. (21.5 × 32.4 cm).
Picker Art Gallery, Colgate University,
Hamilton, New York.
Gift of Edwin J. Safford '58.

5. *Untitled (Study for World's Fair mural
"Medicine")*, c. 1937–39.
Pencil on paper,
9 ¹/₂ × 11 ¹/₂ in. (24 × 29 cm).
Courtesy Allan Stone Gallery,
New York.

6. *Elegy*, c. 1939.
Oil and charcoal on composition board,
40 ¹/₄ × 47 ⁷/₈ in.
(102.2 × 121.5 cm).
Private collection, New York.

7. *Two Men Standing*, 1938.
Oil and charcoal on canvas,
61 × 45 in. (155 × 114.3 cm).
The Metropolitan Museum of Art,
New York. From the Collection of
Thomas B. Hess; Rogers, Louis V. Bell
and Harris Brisbane Dick Funds and
Joseph Pulitzer Bequest, 1984.

8. *Seated Man*, c. 1939.
Oil on canvas,
38 ¹/₄ × 34 ¹/₄ in. (97 × 87 cm).
Hirshhorn Museum and Sculpture
Garden, Smithsonian Institution. Gift
of the artist through the Joseph H.
Hirshhorn Foundation, 1972.
Photo: Lee Stalsworth.

9. *The Glazier*, c. 1940.
Oil on canvas,
54 × 44 in. (137 × 111.7 cm).
The Metropolitan Museum of Art,
New York. From the Collection of
Thomas B. Hess, jointly owned by The
Metropolitan Museum of Art and the
heirs of Thomas B. Hess, 1984.

10. *Two Standing Men*, c. 1939.
Pencil on paper,
13 ³/₁₆ × 16 ¹/₄ in. (33.5 × 41.2 cm).
Private collection, New York.

11. *Seated Woman*, c. 1940.
Oil and charcoal on masonite,
54 × 36 in. (137 × 91.5 cm).
Philadelphia Museum of Art. The
Albert M. Greenfield and Elizabeth M.
Greenfield Collection.

12. *Woman Sitting*, 1943–44.
Oil and charcoal on composition board,
48 ¹/₄ × 42 in. (122.5 × 106.7 cm).
The Art Museum, Princeton
University. Lent anonymously.

13. *Woman*, 1944.
Oil and charcoal on canvas,
46 × 32 in. (116.8 × 81.2 cm).
The Metropolitan Museum of Art,
New York. From the Collection of
Thomas B. Hess, jointly owned by The
Metropolitan Museum of Art and the
heirs of Thomas B. Hess, 1984.

14. *Queen of Hearts*, 1943–46.
Oil and charcoal on fiberboard,
46 ¹/₈ × 27 ⁵/₈ in. (117 × 70 cm).
Hirshhorn Museum and Sculpture
Garden, Smithsonian Institution. Gift
of Joseph H. Hirshhorn Foundation,
1966. Photo: Lee Stalsworth.

15. *Pink Lady*, c. 1944.
Oil and charcoal on panel,
48 ¹/₄ × 35 ¹/₄ in. (122.5 × 89.5 cm).
Private collection.

16. *Woman*, 1943.
Oil on board,
28 ¹/₄ × 23 ¹/₁₆ in. (71.7 × 58.5 cm).
Seattle Art Museum. Gift of Mr. and
Mrs. Bagley Wright.
Photo: Paul Macapia.

17. *Unfinished heads*, c. 1943.
Figure studies on the back of the
pressed wood panel support
of *Black Friday*.
Oil on pressed wood panel,
39 × 49 ¹/₄ in. (99 × 125 cm).
The Art Museum, Princeton
University. Gift of Mr. and Mrs.
H. Gates Lloyd, Class of 1923,
in honor of the Class of 1923.
Photo: Bruce M. White.

18. *The Wave*, c. 1942–44.
Oil on fiberboard,
48 × 48 in. (122 × 122 cm).
National Museum of American Art,
Smithsonian Institution. Gift from the
Vincent Melzac Collection.

19. *Pink Angels*, 1945.
Oil and charcoal on canvas,
52 × 40 in. (132 × 101.5 cm).
Collection of the Frederick Weisman
Company, Los Angeles.

20. *Backdrop for Labyrinth*, 1946.
Calcimine and charcoal on canvas,
16 feet 10 in. × 17 feet
(5.13 × 5.18 m).
Courtesy Allan Stone Gallery,
New York.

21. Pablo Picasso.
Les Demoiselles d'Avignon, 1907.
Oil on canvas,
96 × 92 in. (244 × 233.7 cm).
The Museum of Modern Art,
New York. Acquired through the
Lillie P. Bliss Bequest.
Photograph © 1995 The Museum of
Modern Art, New York.

22. *Untitled Study (Women)*, c. 1948.
Oil on paper,
21 × 32 ¹/₈ in. (53.3 × 81.2 cm).
Frances Lehman Loeb Art Center,
Vassar College, Poughkeepsie,
New York.
Gift of Mrs. Richard Deutsch
(Katherine W. Sanford, Class of 1940).

23. *Pink Lady (Study)*, c. 1948.
Oil on paper on fiberboard,
18 ¹/₂ × 18 ¹/₂ in. (47 × 47 cm).
Collection of Mr. and Mrs. Donald
Blinken, New York.

24. *Two Figures*, c. 1946–47.
Oil, colored chalk and charcoal on
paper,
10 ¹/₂ × 12 ¹/₄ in. (26.6 × 31.2 cm).
Courtesy Allan Stone Gallery,
New York.

25. *Pink Angel*, 1947.
Oil on paper,
10 × 15 in. (25.4 × 38 cm).
Private collection.

26. *Untitled (Three Women)*, c. 1948.
Oil on paper,
20 × 26 ³/₈ in. (51.7 × 67 cm).
Frances Lehman Loeb Art Center,
Vassar College, Poughkeepsie,
New York.
Gift of Mrs. Richard Deutsch
(Katherine W. Sanford, Class of 1940).

27. *Black Friday*, 1948.
Oil and enamel on pressed wood
panel,
49 ¹/₄ × 39 in. (125 × 99 cm).
The Art Museum, Princeton
University. Gift of Mr. and Mrs.
H. Gates Lloyd, Class of 1923, in honor
of the Class of 1923.
Photo: Bruce M. White.

28. *Zurich*, 1947.
Oil and enamel on paper, mounted on
fiberboard,
36 × 24 ¹/₈ in. (91.5 × 61.2 cm).
Hirshhorn Museum and Sculpture
Garden, Smithsonian Institution. The
Joseph H. Hirshhorn Bequest, 1981.
Photo: Lee Stalsworth.

29. *Orestes*, 1947.
Enamel on paper mounted on
plywood,
24 ⅛ × 36 ⅛ in. (61.2 × 91.7 cm).
Collection of Thomas W. Weisel.

30. *Warehouse Manikins*, 1949.
Oil and enamel on buff paper,
mounted on cardboard,
24 ¼ × 34 ⅝ in. (61.5 × 88 cm).
Collection of Mr. and Mrs.
Bagley Wright.

31. *Painting*, 1948.
Enamel and oil on canvas,
42 ⅝ × 56 ⅛ in. (108.2 × 142.4 cm).
The Museum of Modern Art,
New York. Purchase.
Photograph © 1995 The Museum of
Modern Art, New York.

32. *Woman*, 1948.
Oil and enamel on fiberboard,
53 ⅝ × 44 ⅝ in. (136.2 × 113.3 cm).
Hirshhorn Museum and Sculpture
Garden, Smithsonian Institution.
Gift of The Joseph H. Hirshhorn
Foundation, 1966.
Photo: Lee Stalsworth.

33. *Woman*, 1949.
Oil, enamel, and charcoal on canvas,
60 × 47 ⅞ in. (152.4 × 121.5 cm).
Private collection.

34. *Woman I*, 1950-52.
Oil on canvas,
75 ⅞ × 58 in. (192.7 × 147.3 cm).
The Museum of Modern Art, New
York. Purchase, 1953.
Photograph © 1995 The Museum of
Modern Art, New York.

35. *Excavation*, 1950.
Oil on canvas,
80 ⅛ × 100 ⅛ in. (203.5 × 254.3 cm).
The Art Institute of Chicago.
Gift of Mr. and Mrs. Noah Goldowsky
and Edgar Kaufmann Jr.; Mr. and Mrs.
Frank G. Logan Prize Fund.
Photograph © 1992 The Art Institute
of Chicago,
All Rights Reserved.

36. *Asheville*, 1949.
Oil on illustration board,
25 ½ × 32 in. (64.7 × 81.2 cm).
The Phillips Collection,
Washington, D.C.

37. *Collage*, 1950.
Oil, enamel, and metal (thumbtacks)
on cut papers,
22 × 30 in. (56 × 76.2 cm).
Private collection.

38. *Woman*, 1950.
Oil, enamel, and pasted paper on
paper,
14 ⅝ × 11 ⅝ in. (37.2 × 29.5 cm).
The Metropolitan Museum of Art,
New York. From the Collection of
Thomas B. Hess, jointly owned by The
Metropolitan Museum of Art and the
heirs of Thomas B. Hess, 1984.

39. *Figure in Landscape, No. 2*, 1951.
Oil and pencil on paper, mounted on
fiberboard,
33 × 15 ½ in. (83.8 × 39.4 cm).
Hirshhorn Museum and Sculpture
Garden, Smithsonian Institution. Gift
of Joseph H. Hirshhorn, 1966.
Photo: Lee Stalsworth.

40. *Woman II*, 1952.
Oil on canvas,
59 × 43 in. (150 × 109.2 cm).
The Museum of Modern Art, New
York. Gift of Mrs. John D. Rockefeller
3rd. Photograph © 1995 The Museum
of Modern Art, New York.

41. *Woman and Bicycle*, 1952-53.
Oil on canvas,
76 ½ × 49 in. (194.3 × 124.5 cm).
Whitney Museum of American Art,
New York. Purchase.
Photograph © 1996 Whitney Museum
of American Art, New York.
Photo: Geoffrey Clements.

42. *Woman*, 1952.
Charcoal and pastel on paper,
29 ⅛ × 19 ⅝ in. (74 × 49.8 cm).
Musée National d'Art Moderne,
Centre Georges Pompidou, Paris.

43. *Torsos, Two Women*, c. 1952-53.
Pastel on paper,
18 ⅞ × 24 in. (48 × 61 cm).
The Art Institute of Chicago. Joseph H.
Wrenn Memorial Collection.

44. *Woman*, 1953.
Oil and charcoal on paper, mounted on
canvas,
25 ⅝ × 19 ⅝ in. (65 × 49.8 cm).
Hirshhorn Museum and Sculpture
Garden, Smithsonian Institution. Gift
of Joseph H. Hirshhorn, 1966.
Photo: Ricardo Blanc.

45. *Marilyn Monroe*, 1954.
Oil on canvas,
50 × 30 in. (127 × 76.2 cm).
Collection Neuberger Museum of Art,
Purchase College, State University of
New York. Gift of Roy R. Neuberger.
Photo: Jim Frank.

46. *Two Women in the Country*, 1954.
Oil, enamel, and charcoal on canvas,
46 ⅛ × 40 ¾ in. (117 × 103.5 cm).
Hirshhorn Museum and Sculpture
Garden, Smithsonian Institution. Gift
of Joseph H. Hirshhorn, 1966.
Photo: Lee Stalsworth.

47. *Woman as a Landscape*, 1954-55.
Oil on canvas,
65 × 47 in. (165.4 × 119.4 cm).
Collection of Steve Martin.

48. *Composition*, 1955.
Oil on canvas,
79 ⅛ × 69 ⅛ in. (201 × 175.5 cm).
Solomon R. Guggenheim Museum,
New York.
Photograph © The Solomon R.
Guggenheim Foundation, New York.
Photo: David Heald.

49. *Backyard on 10th Street*, 1956.
Oil on canvas,
48 × 58 ½ in. (122 × 148.5 cm).
The Baltimore Museum of Art.
Frederick W. Cone Fund.

50. *Gotham News*, 1955.
Oil on canvas,
69 × 79 in. (175.2 × 200.5 cm).
Albright-Knox Art Gallery, Buffalo,
New York. Gift of Seymour H. Knox,
1955.

51. *Easter Monday*, 1955-56.
Oil and newspaper transfer on canvas,
96 × 74 in. (244 × 188 cm).
The Metropolitan Museum of Art,
New York, Rogers Fund, 1956.

52. *Ruth's Zowie*, 1957.
Oil on canvas,
80 ½ × 70 ½ in. (204.4 × 179.6 cm).
Private collection, USA.

53. *Parc Rosenberg*, 1957.
Oil on canvas,
80 × 70 in. (203.2 × 177.8 cm).
Private collection.

54. *Montauk Highway*, 1958.
Oil and combined media on heavy-
weight paper mounted on canvas,
59 × 48 in. (150 × 122 cm).
Los Angeles County Museum of Art.
Gift from the Michael and Dorothy
Blankfort Collection in honor of the
museum's twenty-fifth anniversary.

55. *Suburb in Havana*, 1958.
Oil on canvas,
80 × 70 in. (203.2 × 177.8 cm).
Private collection.

56. *Untitled (Study for Lisbeth's Painting)*,
c. 1957.
Oil on paper,
12 ½ × 14 in. (31.7 × 35.5 cm).
Courtesy Allan Stone Gallery,
New York.

57. *Lisbeth's Painting*, 1958.
Oil on canvas,
49 ¾ × 63 ¾ in. (126.5 × 162 cm).
Virginia Museum of Fine Arts. Gift of
Sydney and Frances Lewis.
Photo: Grace Wen Hwa Ts'ao.

58. *Lily Pond*, 1959.
Oil on canvas,
70 �5/16 × 80 ⅛ in. (178.5 × 203.5 cm).
The Toledo Museum of Art, Toledo,
Ohio. Purchased with funds from the
Libbey Endowment. Gift of Edward
Drummond Libbey.

59. *Merritt Parkway*, 1959.
Oil on canvas,
80 × 70 ½ in. (203.2 × 179 cm).
The Detroit Institute of Arts. Bequest
of W. Hawkins Ferry.

60. *Black and White Rome*, 1959.
Oil on paper on canvas,
55 ¾ × 40 in. (141.5 × 101.5 cm).
Courtesy Allan Stone Gallery,
New York.

61. *Black and White Rome
(Two-Sided Single L)*, 1959.
Enamel on paper,
27 ¼ × 39 in. (69.2 × 99.1 cm).
Whitney Museum of American Art,
New York. Gift in memory of
Audrey Stern Hess.

62. *A Tree in Naples*, 1960.
Oil on canvas,
80 ¼ × 70 ⅛ in. (203.7 × 178.1 cm).
The Museum of Modern Art,
New York. The Sidney and Harriet
Janis Collection.
Photograph © 1995 The Museum of
Modern Art, New York.

63. *Door to the River*, 1960.
Oil on canvas,
80 × 70 in. (203.2 × 177.8 cm).
Whitney Museum of American Art,
New York. Purchase with funds from
the Friends of the Whitney Museum
of American Art.
Photo: Geoffrey Clements.

64. *Untitled*, 1962.
Oil on canvas,
80 × 70 in. (203.2 × 177.8 cm).
Hirshhorn Museum and Sculpture
Garden, Smithsonian Institution. Gift
of the Joseph H. Hirshhorn
Foundation, 1966.
Photo: Lee Stalsworth.

65. *Rosy-Fingered Dawn at Louse Point*,
1963.
Oil on canvas,
80 × 70 in. (203.2 × 177.8 cm).
Stedelijk Museum, Amsterdam.

66. *Pastorale*, 1963.
Oil on canvas,
70 × 80 in. (177.8 × 203.2 cm).
Private collection, New Orleans.

67. Gianlorenzo Bernini.
Ecstasy of Saint Teresa, 1647–52.
Marble,
11 feet 6 in. (3.5 m) high.
Santa Maria della Vittoria, Rome.

68. *Woman I*, 1961.
Oil on paper with collage,
29 × 22 ³/₈ in. (73.5 × 56.8 cm).
Private collection, New Orleans.
Photo: Owen Murphy.

69. *Woman*, 1965.
Oil, pencil, and charcoal on paper,
79 ¹/₂ × 35 ¹/₂ in. (202 × 90.2 cm).
Private collection.

70. Early stage of *Woman Accabonac*.
Photograph collection of the artist.
Photo: John McMahon.

71. *Woman Accabonac*, 1966.
Oil on paper mounted on canvas,
79 × 35 in. (200.5 × 88.8 cm).
Whitney Museum of American Art,
New York. Purchase with funds from
the artist and Mrs. Bernard F. Gimbel.
Photograph © 1996 Whitney Museum
of American Art, New York.
Photo: Geoffrey Clements.

72. Alberto Giacometti.
Woman with Her Throat Cut, 1932.
Bronze,
8 × 34 ¹/₂ × 25 in. (20.3 × 87.5 × 63.5 cm).
The Museum of Modern Art,
New York. Purchase.
Photograph © 1995 The Museum of
Modern Art, New York.

73. *Woman*, 1964.
Charcoal on paper,
79 × 37 in. (200.5 × 94 cm).
Museum of Contemporary Art,
San Diego. Gift of Lynn and
Danah Fayman.

74. *Woman in a Rowboat*, 1964.
Charcoal on paper,
58 × 35 ¹/₂ in. (147.3 × 90.2 cm).
Collection of James and Katherine
Goodman, New York.

75. *Woman, Sag Harbor*, 1964.
Oil and charcoal on wood,
80 × 36 in. (203.2 × 91.4 cm).
Hirshhorn Museum and Sculpture
Garden, Smithsonian Institution. Gift
of Joseph H. Hirshhorn, 1966.
Photo: Lee Stalsworth.

76. *Untitled*, late 1960s.
Charcoal and pencil on tracing paper,
18 ³/₄ × 21 ¹/₄ in. (47.5 × 54 cm).
Marisa del Re Gallery, New York.

77. *The Visit*, 1966–67.
Oil on canvas,
60 × 48 in. (152.5 × 122 cm).
Tate Gallery, London. Purchased 1969.

78. *Untitled (Crucifixion)*, 1966.
Charcoal on paper,
17 × 14 in. (43.1 × 35.5 cm).
Courtesy Matthew Marks Gallery,
New York.

79. *Untitled (Seated Woman on the Beach)*,
1966–67.
Charcoal on paper,
24 × 18 ³/₄ in. (61 × 47.6 cm).
Collection of Norman and Shelly
Dinhofer.

80. *Two Figures in a Landscape*, 1968.
Oil on paper,
48 ¹/₂ × 60 ⁵/₈ in. (122.5 × 154 cm).
National Gallery of Australia,
Canberra.

81. *Women Singing I*, 1966.
Oil on paper,
36 ¹/₈ × 24 ¹/₄ in. (91.7 × 61.5 cm).
Private collection.

82. *Montauk I*, 1969.
Oil on canvas,
88 × 77 in. (223.5 × 195.5 cm).
Wadsworth Atheneum, Hartford.
The Ella Gallup Sumner and
Mary Catlin Sumner Collection.

83. *Woman*, 1970.
Oil on canvas,
60 × 48 in. (152.5 × 122 cm).
Private collection, New York.

84. *Landscape of an Armchair*, 1971.
Oil on canvas,
80 × 70 in. (203.2 × 177.8 cm).
Courtesy Gagosian Gallery, New York.

85. *Untitled No. 13*, 1969.
Bronze,
15 ¹/₂ × 12 × 4 ¹/₂ in.
(39.5 × 30.5 × 11.5 cm).
Collection of the artist.
Photograph courtesy Willem de
Kooning office.

86. *Cross-Legged Figure*, 1972.
Bronze,
24 ¹/₂ × 17 ³/₄ × 16 in. (62.2 × 45 × 40.5
cm).
Collection of the artist.
Photograph courtesy Willem de
Kooning office.

87. *Clamdigger*, 1972.
Bronze,
57 ¹/₂ × 24 ¹/₂ × 21 in.
(146.1 × 62.2 × 53.3 cm).
Whitney Museum of American Art,
New York. Gift of Mrs. H. Gates Lloyd.
Photograph © 1996 Whitney Museum
of American Art, New York.
Photo: Geoffrey Clements.

88. *Hostess*, 1973.
Bronze,
49 × 37 × 29 in. (124.5 × 94 × 73.5 cm).
Collection of the artist.
Photograph courtesy Willem de
Kooning office.

89. *La Guardia in a Paper Hat*, 1972.
Oil on canvas,
55 ³/₄ × 48 in. (141.5 × 122 cm).
Courtesy Galerie Karsten Greve.

90. *. . . Whose Name Was Writ in Water*,
1975.
Oil on canvas,
77 × 88 in. (195.5 × 223.5 cm).

Solomon R. Guggenheim Museum,
New York.
Photograph © The Solomon R.
Guggenheim Foundation, New York.
Photo: David Heald.

91. *North Atlantic Light*, 1977.
Oil on canvas,
80 × 70 in. (203.2 × 177.8 cm).
Stedelijk Museum, Amsterdam.

92. *Untitled XIV*, 1977.
Oil on canvas,
55 × 59 in. (139.7 × 150 cm).
Collection Mr. and Mrs. Roy
Zuckerberg, New York.

93. *Untitled III*, 1979.
Oil on canvas,
60 ¹/₄ × 54 in. (153 × 137 cm).
Collection of the Frederick Weisman
Company, Los Angeles, California.
Courtesy Margo Leavin Gallery,
Los Angeles.
Photo: Douglas M. Parker Studio,
Los Angeles.

94. *Untitled V*, 1980.
Oil on canvas,
70 × 80 in. (177.8 × 203.2 cm).
Collection of the artist.
Photo: Christopher Burke,
Quesada / Burke, New York.

95. *Pirate (Untitled II)*, 1981.
Oil on canvas,
88 × 76 ¹/₄ in. (223.5 × 195 cm).
The Museum of Modern Art, New
York. Sidney and Harriet Janis
Collection Fund.
Photograph © 1995 The Museum of
Modern Art, New York.

96. *Untitled VI*, 1981.
Oil on canvas,
77 × 88 in. (195.5 × 223.5 cm).
Private collection, New York.

97. *Untitled III*, 1982.
Oil on canvas,
80 × 70 in. (203.2 × 177.8 cm).
PaineWebber Group Inc., New York.

98. *Untitled VI*, 1982.
Oil on canvas,
80 × 70 in. (203.2 × 177.8 cm).
Collection of the artist.
Photo: Christopher Burke,
Quesada / Burke, New York.

99. *Morning: The Springs*, 1983.
Oil on canvas,
80 × 70 in. (203.2 × 177.8 cm).
Stedelijk Museum, Amsterdam.

100. *Untitled XVII*, 1984.
Oil on canvas,
80 × 70 in. (203.2 × 177.8 cm).
Collection Emily Fisher Landau,
New York.

101. *Untitled I*, 1985.
Oil on canvas,
70 × 80 in. (177.8 × 203.2 cm).
Collection of the artist.
Photograph courtesy Willem de
Kooning office.

102. [No title], 1986.
Oil on canvas,
80 × 70 in. (203.2 × 177.8 cm).
Collection of the artist.
Photo: Christopher Burke,
Quesada / Burke, New York.

The Companion to Specialist Surgical Practice

Series edited by

O. James Garden and Simon Paterson-Brown

The content of all eight volumes of the Fifth Edition of the **Companion to Specialist Surgical Practice** is now available both in print and as part of an electronic library. Your purchase of this book allows you to download the fully searchable contents to your desktop, laptop, tablet or smartphone.

Your **Companion to Specialist Surgical Practice eLibrary** is portable: the titles in the series download to your device or you can access online so they are with you whenever you need them.

Your eBook is much more than just 'pictures of pages':

- customize your page views
- search in single books that you have purchased or across any volumes in the series in your collection
- highlight and take searchable notes, and even print and copy-and-paste with bibliographic sup~~~~
- utilize reference lis~~~~ authors, title, source, and often~~~~ electronic full-text availability.

To purchase other eB~~~~ ~~~~actice **eLibrary** please visit~~~~

Surgical Practice

Vascular and Endovascular Surgery

Colorectal Surgery

Hepatobiliary and Pancreatic Surgery

Core Topics in General and Emergency Surgery